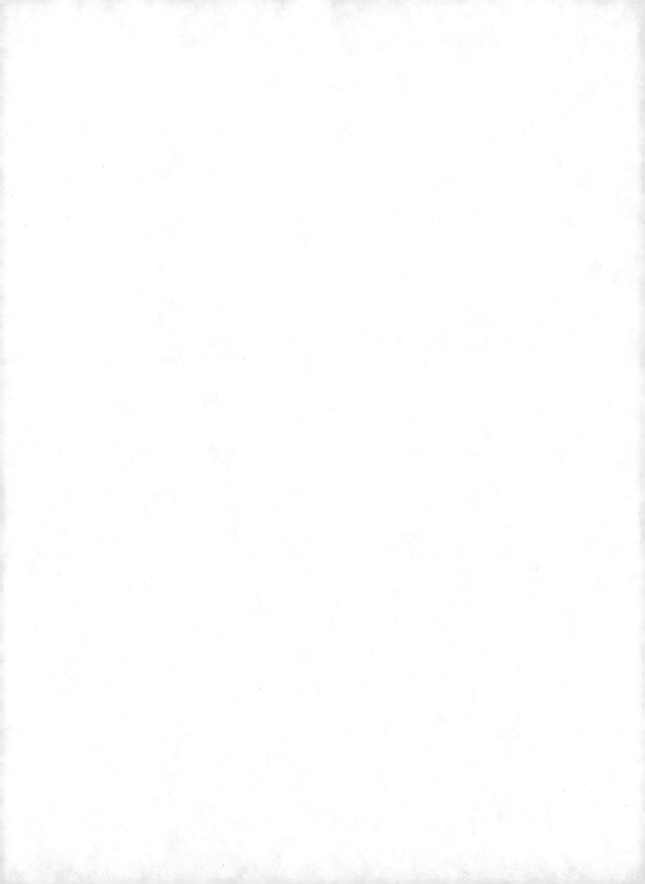

Kirlian Photography
A Hands-On Guide

John Iovine

TAB Books
Division of McGraw-Hill, Inc.
Blue Ridge Summit, PA 17294-0850

HOUSTON PUBLIC LIBRARY

Warning

By participating in the experiments contained in this book, you will be working near high-voltage electricity, which can produce a dangerous or lethal shock. Please be careful and follow all directions and warnings contained within this book. In addition, if you will be developing your own photographs, the processing chemicals involved are dangerous. Follow all manufacturers' directions when developing photographs.

FIRST EDITION
FIRST PRINTING

© 1994 by **TAB Books**.
TAB Books is a division of McGraw-Hill, Inc.

Printed in the United States of America. All rights reserved. The publisher takes no responsibility for the use of any of the materials or methods described in this book, nor for the products thereof.

Library of Congress Cataloging-in-Publication Data

Iovine, John.
 Kirlian photography : a hands-on guide / by John Iovine.
 p. cm.
 Includes index.
 ISBN 0-8306-4456-3 ISBN 0-8306-4457-1 (pbk.)
 1. Kirlian photography. I. Title.
 TR760.I59 1993
 778.3—dc20 93-1472
 CIP

Acquisitions Editor: Roland S. Phelps
Editorial Team: Robert E. Ostrander, Executive Editor
 Andrew Yoder, Book Editor
Production Team: Katherine G. Brown, Director
 Sue Kuhn, Typesetting
 Rose McFarland, Layout
 Jodi L.Tyler, Indexer
Design Team: Jaclyn J. Boone, Designer
 Brian Allison, Associate Designer EL1
Paperbound Cover Design: Carol Stickles, Allentown, Pa. 4429

Contents

Introduction

Imagine walking into your doctor's office. You place your finger into a small device, the doctor hits a button and a few seconds later, your results from over a dozen medical tests pop up onto a computer monitor. In those few seconds, you have been screened for cancer, diabetes, anemia, and a host of other diseases. Sounds far-fetched, perhaps now, but maybe not in the future.

Kirlian photographs capture the imagination. A burst of electricity from a device and a glowing electrical discharge surrounds an object. It transforms ordinary everyday objects into mysterious glowing energy hieroglyphics. It has been claimed that the aura surrounding living subjects might be used in forecasting illness and disease before any physical manifestations of the disease appears. Others claim the overall health of an individual can be determined. Recently, strong inroads have been made in regard to the practical medical usefulness of Kirlian images.

The purpose of this book is to give a broad overview of Kirlian photography. Whether you wish to pursue the scientific usefulness or develop an artistic technique for generating new images, this book will start you on your journey. It shows a number of Kirlian devices that can be built and the techniques to shoot and create Kirlian photographs. In building your own Kirlian equipment, you will have the ability to customize and expand the basic configuration to meet your individual needs.

John Iovine
NYC 1993

1
Electricity

The flow of electrons through a conductor is called *electricity*. We are all familiar with electricity. It powers and causes our light bulbs to glow, radios and TVs to work, trains to run, etc.

Kirlian photography deals extensively with high-voltage electricity. Electricity is used to make electro-photographs, commonly called *Kirlian photographs*.

The image recorded on film is the corona discharge (spark) from the object being photographed. The corona discharge is caused by the high-voltage field and its interaction with matter (electrode and object being photographed). A common name for corona discharge that many people use is *spark*. However, the corona discharge "spark" is a continuous "spark" discharge, rather than a single pulse.

Electrons are one of the three fundamental particles used to describe matter in classical physics. For this book, classical physics will be sufficient. The basic component of matter is the *atom*. Atoms are comprised of three primary particles: the electron, the proton, and the neutron. The electron carries a negative charge of -1.60×10^{-19} C. The proton carries an equal, but opposite or positive charge of $+1.60 \times 10^{-19}$. The neutron is neutral with 0 charge. Typically, the number of protons in an atom equals the number of electrons, which makes the majority of atoms on the earth electrically neutral.

Another difference between protons and electrons, aside from their opposite electrical charges, is mass. The proton is 1836 times more massive than the electron. Because the electron is so light, as compared to the proton, electrons are the moving charges between an electrical potential difference (voltage). It is much easier (1836 times easier) for the potential difference (voltage) to migrate and move the lighter electrons (than the heavier protons) through a conductor.

A simple classical model of the atom is visualized as a miniature solar system. The nucleus comprised of protons and neutrons is at the center of the solar system with the electrons in orbit.

The electrons circle the nucleus in specific orbits called *shells*. Each shell has a maximum number of electrons it can contain. If an atom has one more electron than can fit in a particular shell that electron goes into the next higher shell. Shells are related to electron energy and (as you shall see a little later on) are responsible for the generation of light.

Ions

If an atom gains an additional electron in its outermost shell, it loses its electrical neutrality and becomes negatively charged. An electrically charged atom is called an *ion*. In this particular case, gaining an electron causes the atom to become a negatively charged ion. On the other hand, if an atom loses one of its outer shell electrons, it becomes a positively charged ion.

Static electricity

In conventional electricity, electrons move through a conductor. With static electricity, the charges remain relatively stationary and are concentrated on the surface of the object.

It's easy to generate static electricity. If you rub a rubber rod with fur, the rod acquires a negative charge. The charge is acquired by the migration of electrons off the fur and onto the rubber rod. This leaves the fur with a net positive charge.

If you rub a plastic rod with silk, the plastic rod acquires a positive charge. The silk rubs electrons off the plastic, leaving the plastic with a net positive charge.

There are only two types of charges: positive and negative. The charges' influence on one another can be summed up rather simply: similar charges repel and dissimilar charges attract (Fig. 1-1). Two pith balls are suspended by a fine thread. When there is no charge on either ball, the pith balls have no influence on one another. If both pith balls carry a negative charge, they repel one another. They also repel one another if both pith balls carry a positive charge. If the balls carry opposite charges, they are attracted to one another.

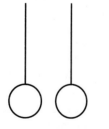

Two pith balls suspended by a fine string. Both balls have no charge.

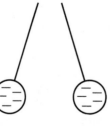

Two pith balls with like charges repel one another.

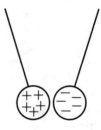

Two pith balls with opposite charges attract one another.

1-1 Charged pith balls.

Conductors and insulators

Materials that allow the flow of electrons through them relatively unimpeded are called *conductors*. Most metals (such as silver, copper, and aluminum) are good conductors.

Insulators do not conduct electricity. Static charges can be rubbed on or off their surfaces, but it sticks to the surface and does not move through the material easily. Examples of insulators are glass, plastic, rubber, and cork.

Electrostatic induction

An *electroscope* is a simple device that can measure small amounts of static charge (Fig. 1-2). An example of electrostatic induction is illustrated in Fig. 1-3. In this illustration, a negatively charged rubber rod is brought close to the metal sphere. This action repels and forces the negative charges on the sphere to move toward the gold leaves. The negative charges on the leaves repel one another opening the leaves up. You can measure the charge by determining how far the leaves opened.

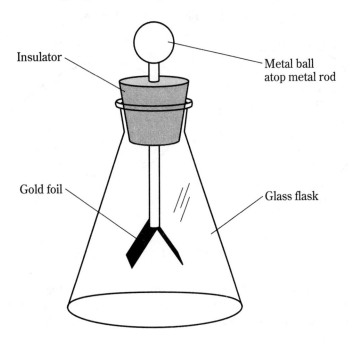

Insulator

Metal ball atop metal rod

Gold foil

Glass flask

1-2 A simple electroscope.

Effects of shape on charge

The shape of an object determines in part how an electrical charge behaves on its surface. If the object is completely round, the electrical charge is evenly distributed over the entire surface. If the conductor has or comes to a point, the charges tend to concentrate around the point. If the voltage is great enough, the air molecules surrounding the point will become ionized and simultaneously repel (ion wind), see Fig. 1-4.

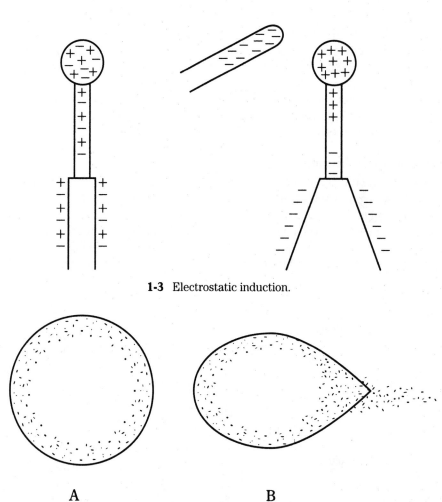

1-3 Electrostatic induction.

A B

1-4 Effects of shape on charge.

This effect is taken advantage of in negative ion generators. Usually, the negative high-voltage source is connected to a needle that bleeds off electrons into the surrounding air creating negative ions.

Coulomb's law

We established that like charges repel and unlike charges attract. The amount of force exhibited between charges (both repulsion and attraction) can be calculated using the equation:

$$F = K \; \frac{Q_a Q_b}{r^2}$$

The equation was first published by eighteenth-century French scientist Charles Coulomb. It is called *Coulomb's Law* in his honor. In the equation:

$$
\begin{aligned}
F &= \text{force in newtons} \\
Q_a \text{ and } Q_b &= \text{the charges} \\
r^2 &= \text{distance apart in meters} \\
K &= \text{constant } 9 \times 10^9 \, N \times m^2/c^2
\end{aligned}
$$

The unit of electric charge is the *coulomb* (abbreviated C). All charges whether positive or negative occur only in multiples of 1.60×10^{-19} C. No particle has ever been found with a charge different from $\pm\ 1.60 \times 10^{-19}$ C or 0. The electron has a charge of -1.60×10^{-19} C, the proton has a charge of $+1.60 \times 10^{-19}$ C.

If 6.25×10^{18} electrons were assembled, their total charge would be -1 C. If 6.25×10^{18} protons were brought together, the total charge would be $+1$ C.

Because charges only occur in multiples of 1.60×10^{-19} C, this amount of charge is given a special name and symbol. The name is the *electron charge* and its symbol is *e*. So:

- $e = 1.60 \times 10^{-19}$ C
- A proton has a charge of $+e$
- An electron has a charge of $-e$

Electric fields

An electric charge fills space with an electric field. A *field* is a concept by which a framework is provided for understanding how forces are transmitted from one object to another across empty space.

Electric fields are visualized as lines of force emanating from positive charges and entering negative charges (Fig. 1-5). The lines of force can be used to visualize the repulsive forces between like charges and the attractive forces between unlike charges (see Fig. 1-6).

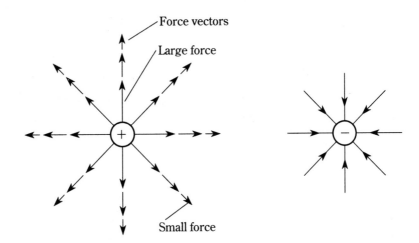

1-5 Lines of force used to illustrate electric fields.

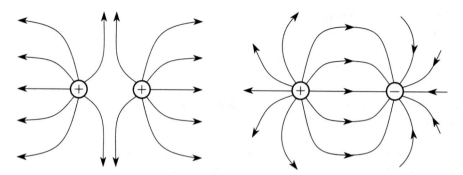

1-6 Using lines of force to visualize attraction and repulsion between electric charges.

Potential energy

Energy is the capacity to do work. If a mass (m) is raised to a height (h) above a reference plane, its potential energy is defined by the equation:

$$Potential\ energy\ (PE) = MGH$$

where G is the gravitational acceleration. With electric energy, the potential energy (height) is established as the difference between charges (positive and negative). The difference in potential (height) is measured in volts (above ground or between positive and negative voltages). A difference of 1 V exists between two points if 1 joule (pronounced like "jewel") is expended moving one coulomb of charge between the two points.

$$V = \frac{W}{Q}$$

where: V = volts
 W = joules
 Q = coulombs

So, if 24 joules is expended moving two coulombs of charge, what is the voltage between these two points?

$$V = 24/2$$
$$V = 12\ V$$

Voltage is often referred to as the height in which an electron can fall to ground (0 voltage). *Current* is the quantity or amount of electrons falling at any particular moment. It is measured in amperes abbreviated as the symbol I. One ampere is one coulomb or 6.25×10^{18} electrons passing a point in one second.

Resistance

The resistance to the flow of electric current is measured in ohms. Georg Simon Ohm was a German physicist who discovered the relationship between voltage, resistance, and current.

$$I = \frac{V}{R}$$

where: I = Current
 V = Volts
 R = Resistance

Given any of the two above values, the third value can be easily calculated using one of these derivative formulas.

$V = I/R$
$I = V/R$
$R = V/I$

As an example, if you connected a 9-volt battery through a 100-ohm resistor, what current would flow (Fig. 1-7)? Looking at our formulas, you could use $I = V/R$ to find the answer. In this case, the current equals 9/100 = 0.09 amperes. Another way to write 0.09 ampere is 90 milliamperes (mA).

If you changed the resistor to 1000 ohms, the current would drop to 9/1000 or 9 mA (0.009 amperes).

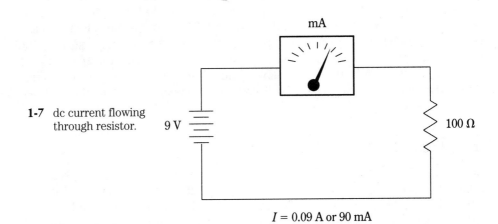

1-7 dc current flowing through resistor.

I = 0.09 A or 90 mA

Capacitors

A *capacitor* consists of two conducting surfaces separated by an insulating material called a *dielectric*. Capacitors have the ability to store electric charges.

Figure 1-8 illustrates a simple capacitor. When the switch is closed, electricity cannot flow across the dielectric, but it charges the plates in the capacitor. The capacitor blocks dc current from flowing through the circuit. The amount of charge stored is proportional to the size of the capacitor plates, the dielectric between them, and the battery voltage.

Capacitance is measured in *farads (F)*, named in honor of Michael Faraday (1791-1867). A 1-F capacitor connected to a 1-volt supply will store 6.25×10^{18} electrons.

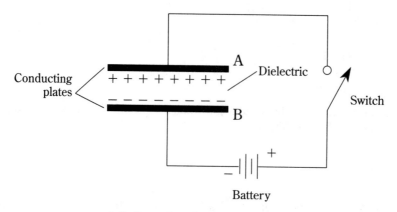

1-8 Operation of simple capacitor.

In electronics, a farad is typically too large of a value to use. So, microfarad (μF) 10^{-6} (0.000001 F) and picofarad (pF) 10^{-12} (0.000000000001 F) capacitors are made and used in electronic circuits.

The diagram of this simple capacitor looks similar to a Kirlian photo set-up. The voltage potential is increased between plates A and B. Plate B is at ground voltage (0) with reference to plate A. When the potential difference becomes high enough, the insulating ability of the dielectric is overcome and a spark jumps between the two plates. If the high voltage potential is supplied continuously, the sparks ionize the air, making it conductive to the flow of electrons. This creates the corona discharge that emits the blue violet glow. To record the image, a sheet of film is placed between the plates.

dc electricity

Alessandro Volta invented the electric battery. Batteries use chemical solutions called *electrolytes*. Electrolytes contain many ions. If table salt (NaCl) is dissolved into ordinary water, the salt disassociates into positive sodium ions and negative chlorine ions. If two dissimilar metal plates, such as copper and zinc, are immersed into the salt solution, an electrical potential is created (Fig. 1-9). The potential is created by the migration of positive ions to one metal and the negative ions to the other. If the two plates are connected by an external conductor, electrons will flow from the negative electrode to the positive electrode.

Magnetism

Several thousand years ago, the Greeks discovered a black ore in the district of Magnesia in Asia Minor. This black ore was a natural magnet. The magnet attracted iron and could attract or repel similar ore samples like itself. The basic properties of magnets are:

1. Magnets have two poles, North and South.
2. Similar poles repel, dissimilar poles attract. Magnets generate fields similar to electric fields (Fig. 1-10).

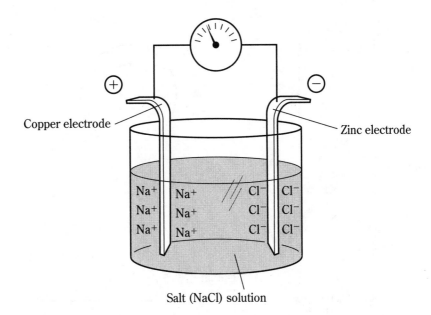

1-9 Simple electrochemical cell.

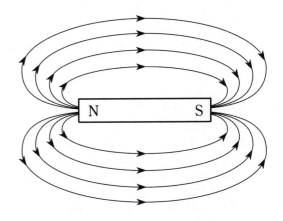

1-10 Lines of force used to illustrate magnetic fields.

Electromagnetic induction

A moving magnetic field across a conductor surface causes an electric current to be made in the conductor. As the conductor cuts across or is cut by the magnetic field, it induces an *electromotive force (EMF)*.

ac electricity

The generation of *alternating current (ac)* electricity is manufactured through the principle of electromagnetic induction and is illustrated in Fig. 1-11. A coil of wire is rotated in a magnetic field. If the coil is rotated at 3600 RPM, a 60-Hz sine wave is generated. Standard household electricity in America is 60 Hz.

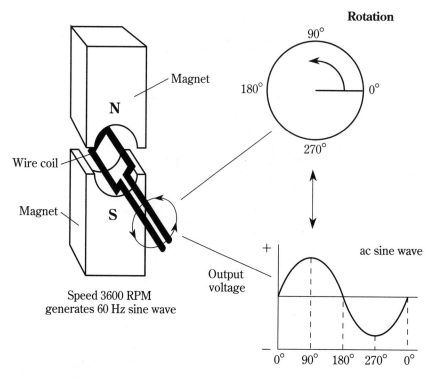

1-11 Generating ac current through electromagnetic induction.

ac current and capacitors

Capacitors behave differently with ac current than they do with dc current. During the first part of an ac cycle, the capacitor charges in a manner that is similar to the dc charging described before. The capacitor might completely charge by the time the applied ac voltage passes it peak and starts to decrease. As the ac voltage decreases, a point will be reached when it is less than the charge on the capacitor. This allows the capacitor to start discharging through the ac voltage source.

The capacitor might completely discharge by the time the ac voltage reverses polarity. Because the reversed polarity is the same as the source polarity, the voltages add and quickly discharge the capacitor; then, charging begins again with the reversed polarity.

When the ac source changes polarity again, the capacitor is discharged again and the whole process is repeated. The process of charging, discharging, and recharging a capacitor from an ac voltage source gives the effect as if current was actually flowing through the capacitor. As the frequency of the ac source is increased, the current flow increases.

The resistance of a capacitor to ac current is called *capacitive reactance*. Its value decreases as the applied frequency increases. It is determined by the capacitance of the capacitor and the frequency of the applied voltage:

$$X_c = \frac{1}{(6.28\,f \times C)}$$

where: f = Frequency in hertz

C = Capacitance in farads

Notice that if the applied voltage has a frequency of 0, which is to say dc voltage, the equation equals 1/0, which is unsolvable—it equals infinity. Infinite resistance in a circuit acts like an open or blocked circuit, which is the way the capacitor acts in a dc circuit.

Let's do one example with ac frequencies. The values in the equation are C equals 1 μF (0.000001 F), the frequency (f) equals 2500 Hz. So, $X_c = 1/(6.28 \times 2500 \times 0.000001) = X_c = 59\ \Omega$. If you change the capacitance to 30 pF or 0.00000000003 F, the capacitive reactance (X_c) now jumps to 2,100,000 Ω (2.1 MΩ).

Inductors and transformers

An *inductor* is basically a coil of wire. Sometimes a soft iron core is added to increase the magnetic effects. When a current flows through an inductor, a magnetic field is established around it. Assuming that another inductor is close to the first inductor, a voltage or EMF is induced in the second inductor every time the magnetic field from the first inductor cuts through it.

Transformers are a major class of inductors that operate on this principle of inductance (Fig. 1-12). Usually, the two induction coils in a transformer share a common iron core. This improves the magnetic interaction between the inductors. If the current flowing through the primary coil of the transformer is fluctuating, then a fluctuating current will be induced in the secondary coil.

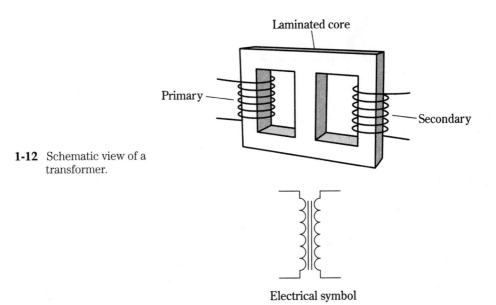

1-12 Schematic view of a transformer.

Transformers are used extensively in electronics. By varying the number of windings (wire turns) in the primary and secondary coils, different voltages and currents can be induced in the secondary coil (Fig. 1-13).

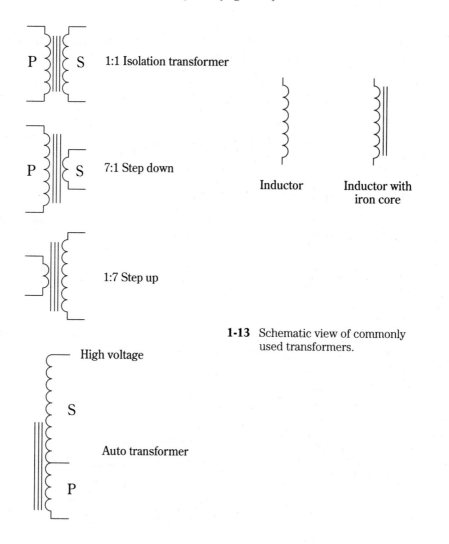

P }{ S 1:1 Isolation transformer

P }{ S 7:1 Step down

1:7 Step up

Inductor Inductor with iron core

1-13 Schematic view of commonly used transformers.

High voltage

S

Auto transformer

P

In the *isolation transformer,* the same number of wire turns are used in the primary and secondary coils. So, the voltage and current are transferred unaltered.

In the *step-down transformer*, there are more windings in the primary coil than in the secondary. This reduces or "steps down" the induced voltage and current in the secondary coil.

The *step-up transformer* is the opposite of the step-down transformer. In this transformer, there are more windings in the secondary coil than the primary. The interaction is that the voltage in the secondary is boosted above the voltage in the primary. The step-up transformer does not create power from nothing. When the

voltage is boosted, the current is reduced. The power output from any transformer cannot exceed the power being input.

The last transformer example here is the *auto transformer.* This transformer is important because it is the type of transformer used in Kirlian circuits to generate high voltage. The auto transformer is a special class of transformer because it uses a single wire winding for both its primary and secondary coils. The primary inductor in the auto transformer is made by connecting a wire at a few hundred turns on the inductor (Fig. 1-13). The secondary coil uses the entire winding, which consists of several thousand turns of wire.

When the primary coil is energized, it sets up a magnetic field. When the current turns off, the magnetic field collapses and induces a high voltage in the secondary windings.

The reason this transformer is called an auto transformer is because it is self (or auto) inductive (using a single winding), not because it is used in an automobile. Although automobiles do use this type of transformer as an ignition coil, the fact that it is called an auto transformer is just coincidence.

Impedance

Circuits with capacitors and inductors have resistances more complex than the simple circuits looked at earlier. The resistance of the components depends upon the frequency at which the circuit operates. So, *impedance* can be considered as an ac resistance. The human body impedance varies depending upon the frequency at which the Kirlian device is operating.

RC filters

A *filter* is a circuit that allows some frequencies to pass through while blocking other frequencies. A simple capacitor would be considered a filter because of the way it blocks dc current while allowing ac current to pass through.

Figures 1-14 and 1-15 show two types of filters made with a resistor and capacitor. Figure 1-14 is a high-pass filter. This means that high frequencies are passed easily while low frequencies starting at the cutoff frequency meet with increasing resistance.

These simple RC filters are not perfect, they do not have sharp cut-off frequencies; rather, they tend to drop off gradually in a slope. A formula for finding the cutoff frequency for both types of filters is $Fc = 159,000/(RC)$, where R = resistance in megohms and C = capacitance in microfarads.

Figure 1-15 shows the configuration and slope of a low-pass filter. At high frequencies, the capacitor has very little resistance and the signal drops to ground. This provides very little signal output because the capacitor acts like a short circuit at these high frequencies. At low frequencies, the capacitor has a high resistance that allows the signal to appear at the output.

Diodes

A *diode* is a simple semiconductor. They allow the flow of current in only one direction (Fig. 1-16).

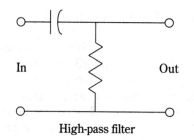

High-pass filter

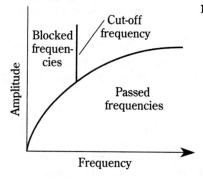

1-14 RC high-pass filter.

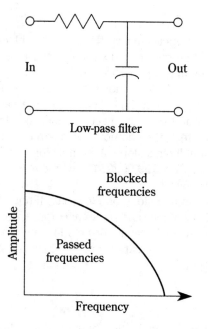

Low-pass filter

1-15 RC low-pass filter.

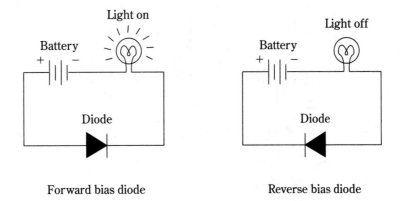

1-16 Operation of the diode.

Light

Light is an enigma—depending upon how light is observed will cause it to exhibit one of its two conflicting natures: wave and particle (Fig. 1-17).

Visible light is only a small portion of the entire electromagnetic spectrum, see Fig. 1-18. The light we are concerned with is the light generated by the corona discharge in Kirlian photography.

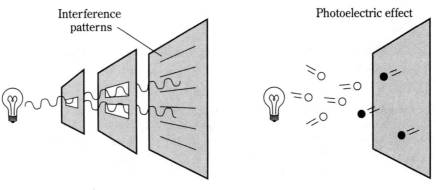

1-17 Duality of light, depending on the method of observation.

Atomic energy transitions

Atoms can absorb and emit energy. When an atom absorbs energy one of its electrons jumps to a higher energy level. Using the solar system model of the atom again, when the electron absorbs energy, it instantly jumps to a larger orbit. An atom that has absorbed energy is said to be in an *excited state*. When the excited atom emits energy, the electron jumps back down to its normal ground state. Atoms can only absorb specific wavelengths or packets of energy that correspond to the energy levels its elec-

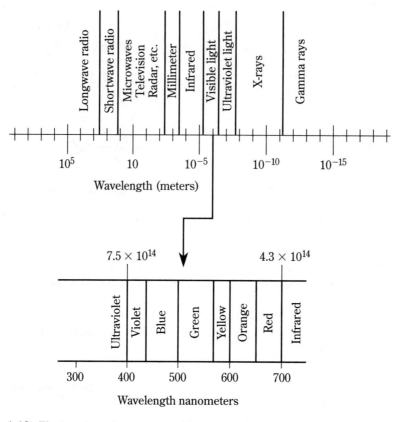

1-18 Electromagnetic spectrum with an extended view of the visible light portion.

trons can jump. The wavelength of the energy absorbed or emitted is inversely proportional to the energy transition of the electron. Small energy jumps correspond to long wavelength energy packets (photons). Energy transitions are measured in electron volts, abbreviated *ev*. Visible light might be considered as long wavelength photons.

To approximate the transitional energy in *ev* to wavelength in nanometers use:

$$1\ ev = 1242\ nm$$

Absorption and emission spectra

Hydrogen is the simplest atom, composed of a single proton nucleus and one orbital electron. This simple atomic structure provides an easy absorption and emission spectra that will complement our understanding of atomic transitions.

Hydrogen gas can only absorb radiation (energy) that matches the transitional energy levels its electron is capable of jumping. The dark line spectra (Fig. 1-19) shows the frequencies of light that hydrogen gas absorbs. Imagine a broad spectrum light being passed through a transparent container of hydrogen gas. If you split the light with a prism after it passed through the gas, you would project the dark line

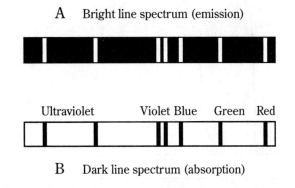

A Bright line spectrum (emission)

Ultraviolet Violet Blue Green Red

B Dark line spectrum (absorption)

(A) Emission and (B) absorption
spectrums of hydrogen.
Each dark line in the absorption
spectrum corresponds to a bright
line in the emission spectrum.

1-19 Light and dark spectra of hydrogen gas.

spectra in Fig. 1-19. Each dark line represents a frequency of light absorbed from a broad spectrum light source.

Conversely, when hydrogen is excited, it emits radiation (light) at those same exact frequencies, see emission spectra Fig. 1-19. Every element has its own unique energy levels, which emit specific radiation wavelengths.

Corona discharge spectra Air is composed mainly of nitrogen (78%) and oxygen (21%). The corona discharge in Kirlian photography excites the nitrogen gas in the atmosphere. The electrostatic discharge appears to the eye as blue-violet. The spectra emitted by the nitrogen falls predominantly in the ultraviolet portion of the electromagnetic spectrum between 280 and 450 nanometers.

Cold electron emission The corona discharge spectra is caused by *cold electron emission.* This happens when a strong electric field exists between two conductive plates. If the field is strong enough, electrons can be ejected from the emitter (negative plate) surface. In Kirlian photography, the subject often takes the place of the negative plate. The ejected electrons accelerate toward the positive plate, ionizing and raising the energy level of the air molecules. When the excited nitrogen gas atoms fall back to their ground state, they emit light energy predominantly in the ultraviolet portion of the spectrum.

To see how this clearly applies to image formation in Kirlian photography, look at Fig. 1-20. Most of the discharge takes place at the air gap formed between the finger and the film. Aside from the spectral emission from the nitrogen in the atmosphere, there is an additional spectra that can be accounted for. The air adjacent to the finger forms a "microclimate." The microclimate has impurities evaporating or vaporized under the corona discharge from the finger. The impurities range from compounds and electrolytes from sweat and oil glands on the skin. As the electrical potential initiates a discharge, the microclimate also ionizes.

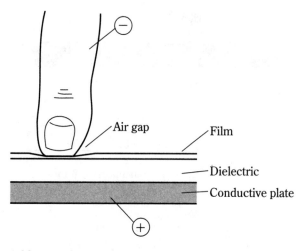

1-20 Air gap around finger, where corona discharge is generated.

Corona formation in Kirlian photography

The nature of the corona discharge and spark formation (called *streamers* in Kirlian photography) is a fairly complex phenomenon. To examine spark formation definitively is beyond the scope of this book. However, the primary mechanisms involved in the process are worth looking at.

When the electrostatic field density in air exceeds a certain value, a discharge of blue violet appears near the adjacent metal surfaces. This discharge is called *electrostatic corona* or *corona discharge.* The following chart is an approximation of kilovolts vs gap distance between a high-voltage electrode and a ground electrode to create an electrostatic corona. A bit higher voltages (than depicted in the following table) would cause streamer (sparks) formations.

Voltage	Distance
2500 V	0.06"
5000 V	0.12"
7500 V	0.25"
10,000 V	0.50"

With high voltage, much depends on the configuration and shape (radius) of the two electrodes. For instance, two point electrodes facing one another would require greater distance between the electrodes than illustrated in the previous chart to prevent streamer formation.

The spark (streamer) process begins when the potential difference between the plates is great enough for the cathode (negative plate) to eject a free electron. The free electron is attracted and accelerates toward the anode (positive plate). There are a few different reactions that the electron might undergo or cause while traveling toward the anode. Although these reactions are happening simultaneously, they vary in the percentage of the overall spark (streamer) formation.

One reaction is that the accelerating free electron collides and excites atoms or molecules of air. This raises the atom's outer shell electrons to a higher energy level. The atoms typically stay in this excited state for approximately 10^{-8} seconds before emitting a photon of energy and returning to its ground state. This reaction generates the ultraviolet light observed with corona discharges in nitrogen atmospheres. In the region where the corona appears, the air is electrically ionized and is a conductor of electricity.

Electronic collisions between atoms and free electrons can also produce positive and negative ions. If an atom or molecule of air captures a free electron, it becomes a negative ion. If, however, a collision with an electron knocks out an existing outer shell electron, it becomes a positive ion. When a positive ion is created, it also has an additional free electron accelerating toward the anode (Fig. 1-21). This new free electron is just as capable of colliding with and causing more reactions as the original free electron. In the streamer formation, this causes an exponential growth of free electrons and positive ions. The exponential growth process is called an *avalanche*.

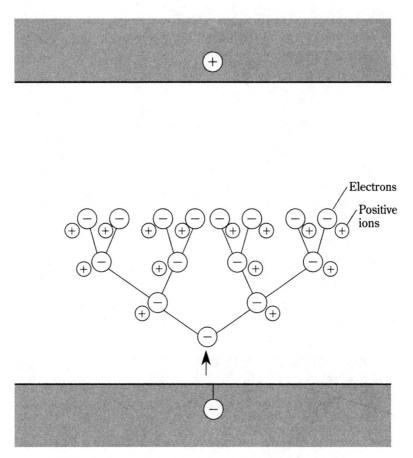

1-21 Emission of electron between high-voltage plates.

The positive ions travel 100 times slower than the free electrons as a result of their greater mass. The positive ions travel toward the cathode as the electron travels toward the anode, forming what is commonly called *streamers* (Fig. 1-22).

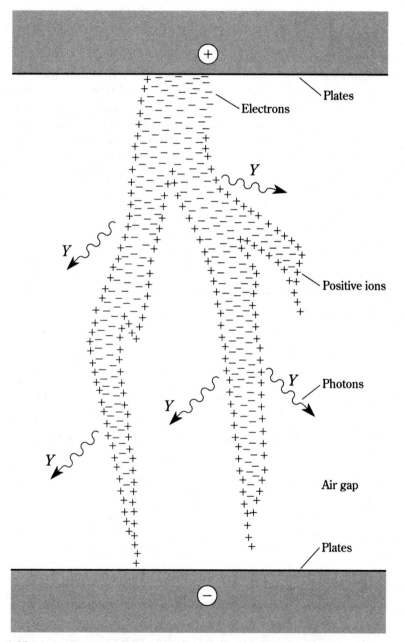

1-22 A cross section of electrical streamer between the high-voltage plates.

Polarity

Polarity of the discharge has an effect on the photography of the streamers. Figure 1-23 illustrates the streamer formation when the object is more positive than the high-voltage plates. The streamers are large and appear to expand from the object.

Figure 1-24 illustrates the opposite case, where the object being photographed is more negative than the high-voltage plate. The streamers appear to converge to the object.

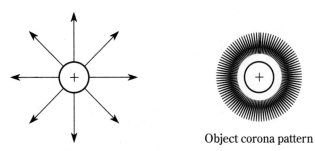

Object corona pattern

1-23 A streamer pattern generated around object that is more positive than the high-voltage plate.

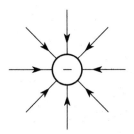

Object corona pattern

1-24 A streamer pattern generated around object that is more negative than high-voltage plate.

2
What is Kirlian photography?

Kirlian (pronounced kur'-lee-uhn) *photography*, is sometimes called *electro-photography, electronography, electromagnetic discharge imaging (EDI)*, and *radiation field photography*. It is commonly called *Kirlian photography* in honor of the Russian researchers Semyon and Valentina Kirlian, who pursued and developed this method of photography for over 30 years. Although they were not the first to work with this method of photography, they were the first to discover many interesting aspects pertaining to it, and they devoted a lifetime to studying its potential.

Kirlian photography uses high-voltage, low-current electricity to expose film. The high-voltage electricity creates a corona discharge around the object being photographed. Because the object is usually in direct contact with the film, the film accurately records the corona discharge from the object. Figure 2-1 illustrates the basic Kirlian arrangement. The exposure plate is made out of a conductive material, usually a metal with a thin layer of insulating material (dielectric) on top. The film lays on top of the exposure plate, emulsion side up (facing the object to be photographed). The object is placed on the film. The high-voltage source is connected to the plate. If the object is inanimate, it is connected to a ground. The Kirlian device is turned on for a short time to make the exposure. When the film is developed, the resulting picture or transparency is a Kirlian photograph.

This simple illustration shows that Kirlian photography doesn't require a lens system or camera. In many ways, it is similar to taking x-ray photographs (radiology).

Kirlian photography: a short history

The beginnings of electro-photography can be traced back to the late 1700s. At this time, Georg Christoph Lichtenberg appears to have been the first to observe electro-photographs. Lichtenberg made note of his observations of pictures made in dust created by static electricity and electric sparks.

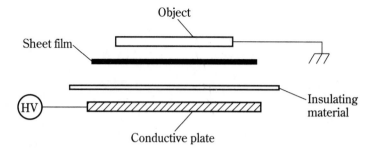

2-1 Schematic view of Kirlian photography set-up.

Nicola Tesla (1880) photographed many corona discharges using his famous Tesla coil. In the early 1900s, Russian engineer and electrical researcher Yakov Narkevich-Todka exhibited interesting electro-photographs he made. A little later (but around the same time) Dr. F.F. Strong of Tufts University Medical School used a Tesla coil to make electro-photographs of his hand.

Russian researchers Semyon Davidovich Kirlian and his wife Valentina began their work with high-voltage photography by accident in 1939. Semyon Kirlian was an electrical repairman in the city of Krasnodar. He had been called to do a repair at a local research institute. While at the institute, he happened to see a demonstration of a high-frequency device used for electrotherapy. As a patient underwent treatment, Kirlian noticed small flashes of light between the patient's skin and the machine's glass electrodes. Kirlian wondered if he could photograph that light. Kirlian substituted a metal electrode for the glass one used in the machine to prevent exposing the film. Then, using himself as a subject, he was able to photograph the corona discharge.

Kirlian collaborated with his wife for over 30 years of developing equipment and studying electro-photography. They made instruments to examine high-frequency currents on living tissues as well as on inanimate materials.

The Kirlians' work was first made known to the general public in this country by a book published in 1970 titled "Psychic Discoveries Behind the Iron Curtain" by Sheila Ostrander and Lynn Schroeder. The Kirlians claimed that this type of photography could be used as a medical diagnostic tool, stating that disease in subjects showed in photographs as a modified or disrupted pattern of discharge, before obvious symptoms became manifested in the subject. Naturally this claim generated much interest in this country. According to the Russian literature, different parts of the body yield different color corona discharges. The skin over the heart area gives a deep blue, the armpits a greenish blue, and the hips an olive tone.

However, more interesting than this was a second claim known as the *phantom leaf*. Here, a small section of a leaf is removed before photographing, but in the subsequent Kirlian photo, the missing section of the leaf appears as a ghostly apparition.

Dr. Thelma Moss, a parapsychologist at UCLA read *PDBIC (Psychic Discoveries Behind the Iron Curtain)* in the early 1970s and became enthusiastic. Dr. Moss traveled to Russia to visit the researchers named in the book. Although she wasn't allowed by the Russian government to meet with Semyon Kirlian or his wife, she did meet with Dr. Victor Inyushin, a biologist at Kazah State University in Alma Ata. Dr.

Inyushin supports the idea that all living matter has not only a physical body, but also an energy body or bio-plasma.

She also met Victor Adamenko, a bio-physicist and colleague of Inyushin. Adamenko correlated the flares shown in Kirlian to ancient acupuncture charts. This agrees with discoveries made independently by American researcher Dr. Robert Becker (see chapter 7). Although he is in disagreement with Inyushin theory of bio-plasma, he feels the phantom leaf can better be explained by a holographic theory.

Dr. Moss had to work around official imposed restrictions placed on her by the Soviet government. She was not allowed to visit the laboratory or university where the work with electro-photography was being carried out and so was unable to observe any experiments or equipment firsthand. The scientists were gracious and gave Dr. Moss copies of their published works and any other pertinent literature available, including schematics for a few Kirlian devices.

Upon returning to America, she had the literature translated to English and tried to have the Kirlian device built from the schematic. The electronics people she contacted told her the device couldn't be built from the Russian schematics or that there was some important piece of information missing from the drawing. They also stated that (in general) the high-voltage high-frequency electric field would be lethal to life and anything placed in it would burn or be frazzled. It was the expert's belief and advice that the entire idea of Kirlian photography was unfeasible.

Several months later, an adult education student, Kendall Johnson, approached Dr. Moss for additional information on the Kirlian process. Dr. Moss had given him a copy of one of the simpler schematics of a Kirlian device that she had received in Russia. A few weeks later Johnson returned with a Kirlian photograph. Despite his lack of electronics experience, or more likely because of it, Johnson was able to rig up a simple device to do the "unfeasible."

This began a collaboration between Kendall Johnson and Thelma Moss. Johnson continued to improve and refine his Kirlian devices. Dr. Moss used Kirlian photography to investigate acupuncture, bio-energy transfer and faith healing. She published a book titled *Probability of the Impossible* in 1974 on this and other experiments. Kendall Johnson also published a book on his research into Kirlian photography in 1975.

Directions: art and science

There are two main directions that can be taken in Kirlian photography. One is to use Kirlian photography for special effects photography. The other is to investigate the potential of this method of photography for its scientific value.

Aesthetics and pictures

Using the Kirlian technique for special effects photography is easier than pursuing it for its scientific value. Many parameters that must be controlled and recorded for research are ignored when shooting for special effects. Aesthetically, the Kirlian technique can be used to achieve interesting special effects photographs. This book shows you how to build the equipment and the techniques to create a large variety of Kirlian photographs.

Scientific inquiry

There was a flurry of research on Kirlian photography in the early 1970s. However, most of this experimentation was not under controlled laboratory conditions or using calibrated laboratory-grade equipment. Unfortunately, this allows for many random variables to influence the outcome (corona discharge) of the experiments, this invalidated the work and conclusions drawn from it. In order for science to accept any data, the research and its results must be repeatable by other scientists. The only way this is accomplished is by using the scientific method with measured and controlled parameters.

Pursuing Kirlian photography for its scientific value is a harder road to travel. Any reports, except those which debunk Kirlian photography, will be met with a fair amount of skepticism from the scientific community. So, it becomes important to keep scrupulous records and control over any scientific experiments.

Kirlian photography has the potential to become a scientific instrument. Notice the operative word "potential" in the last sentence. Despite any claims to the contrary, this type of photography is not, as of yet, used for any medical diagnostic purposes. There are only a small fraction of medical researchers with whom their data draws conclusive results.

For the most part, the patterns and "aura" of electro-photographs are predominately determined by conductivity of the object, pressure on the plate, and moisture content of the air. When looking for subtle differences in corona patterns to make diagnostic analysis, it is necessary to control all the variables that might produce an erroneous pattern.

The key for doing scientific research is to first control or measure the variable factors involved in the creation of the corona discharge such as conductivity or impedance of object, atmospheric pressure and humidity, frequency of discharge, pulse width, voltage, current, polarity, exposure time, film type, development, and chemistry used. With these factors nailed down, you can be assured that variations in the corona discharge or Kirlian aura are from the organism or object under test. This will lay down a usable foundation of information. In fact, Kirlian photography has already been shown to be useful for some types of medical and nondestructive testing.

In researching this book, I have run across many claims for Kirlian photography; some of these claims are not backed up by the proper test data required or double bind experiments. This renders these "observations" null and void by the scientific community.

Remember, in order to be taken seriously in the scientific community, and rightfully so, the experiments must be performed in a repeatable manner. This means that as many variables as possible are either measured or controlled so that another scientist can repeat your experiment and achieve the same results.

Cold electron emission

It is generally well accepted that the Kirlian aura is created by *cold electron emission.* The high-voltage field initiates a few electrons to jump across the charged electrodes (cold electron emission). The electrons accelerate across the field, ionize the air, and start an avalanche between the electrodes. The recombination of electrons

and ions emits photons of light and the discharge appears to the eye as blue-violet light. However, this light is only a portion of the total light generated. The discharge is rich in ultraviolet light that we cannot see. The ultraviolet light is generated by the high percentage of the nitrogen gas that exists in the air. As far as I know, no one has done any extensive UV spectrographic testing of this light for diagnostic purposes. This might be another area for research. The color of the discharge might be changed by shooting Kirlian photographs under different atmospheric gases. If someone would attempt to do this, I would strongly advise them to use non-flammable inert gases (such as carbon dioxide, neon, helium, etc.).

Whether the cold electron emission is showing another physical facet of living matter or tissues (bioplasma) is the question that still remains unanswered. To arbitrarily conclude, as some scientists have done, that the discharge carries no new information about living organisms, based upon the fact that nonliving materials also give a similar aura discharge is at best being closed minded.

Color in Kirlian photographs

Many Kirlian photographs show a whole range of colors, including reds, greens, blues, and white. If the discharge is predominately blue-violet, where are these other colors coming from?

To answer this question, you must examine the structure of color film. Color films are made with three separate silver halide layers. Each layer is designed to respond to a specific color of light: one for red, one for green, and one for blue (Fig. 2-2). This arrangement works very well when exposing film to light in a standard camera. The colors in the image projected onto the film plane are accurately recorded in the film layers.

With Kirlian photography, the electrical discharge generates light by photoionization of nitrogen gas. This light contains a high component of UV light. If the film on top of the exposure plate buckles slightly, it creates an air gap where photoion-

Color film structure

| Protective overcoat |
| Blue sensitive emulsion |
| Yellow filter |
| Green sensitive emulsion |
| Red sensitive emulsion |
| Antihalation layer |
| Film base |

2-2 Schematic view of color film.

ization can occur. The buckling can occur from too much pressure or uneven pressure from the object placed on top the film. The UV light created in the air gap can activate the silver halide crystals from the backside of the film forming a red latent image in the back layers, regardless of the color of the discharge.

Making Kirlian photographs

The procedure for exposing film to create Kirlian photographs remains pretty much the same, regardless of the device you use. Figure 2-1 illustrates the photographic Kirlian setup. The bottom plate is an exposure plate. This is typically constructed of single-sided copper-clad board. Next is an insulating layer of material. If a copper-clad board is used, the insulating layer is the phenolic material of the copper-clad board. In other words, the board is turned copper side down and the phenolic material becomes the insulating dielectric layer. However, the material and thickness of the insulating layer can be made variable by positioning the exposure plate copper side up and using whatever dielectric material you want on top of the copper surface.

The next layer is the film. Most of the time 4"-×–5" color transparency film (6118 or 6117) is used to generate color transparencies. However black-and-white film and paper (as well as color film and paper) can be used as well. The size of the recording film or paper is restricted by the size of the exposure plate. The recording medium (film or paper) is placed emulsion side up, facing the object. Remember that the emulsion side faces the object or the subject that you are photographing. The object or subject is placed on top of the recording medium. The HV source is turned on for a short time to expose the film.

3
First Kirlian device

This first Kirlian device is the simplest of the three devices outlined in this book to construct and operate. Even though this device is simple, it can also be used with the transparent electrode or with Polaroid 600 film to make instant color Kirlian pictures.

This device, as well as the others, uses all types of 4"-x-5" sheet film, color print film, transparency (slide) film or black and white film. You can also use standard photographic paper.

Although you can see the corona discharge (aura) visually if you build one of the transparent electrodes, if you want to record images with a standard 35 mm or video camera, I recommend you use one of the other two Kirlian devices. You can see the aura through the transparent electrode, but the flashes are too fleeting to make a constructive image on film or video.

The exception to this is if you use a light enhancer in front of the camera. Light enhancers can amplify the available light 20,000 to 75,000X, which will make the flashes quite visible. Another exception is when film speed is increased beyond today's commercially available ISO 1600 film. Faster films (such as ISO 3200 or ISO 6400 and beyond) can record the fleeting flashes of the corona discharge. The last exception is the evolution of electronic photography using CCD imaging chips that record images electronically instead of on film. The photographic imaging chips have the potential to gather and record light like the light enhancers that were covered previously.

Circuit construction

What makes one circuit simple and another complex is the amount of components the circuit contains. This circuit uses very few components. Take a look at Fig. 3-1. It would be difficult to find a simpler Kirlian device that performs as well.

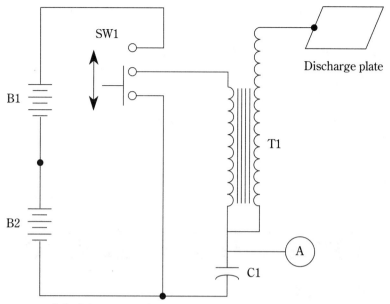

3-1 Schematic of the manually triggered Kirlian device.

The protototype device was built on a single piece of wood measuring 8"×10"×¾" thick (Fig. 3-2). Batteries B1 and B2 are 67.5-V photo batteries. The batteries are wired together in series to produce a total voltage of 135 V.

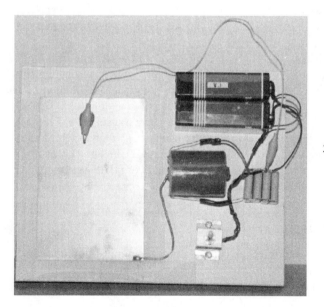

3-2 Photo of manual Kirlian device.

If the photo batteries are not available, you might want to try wiring six or seven standard 9-V batteries in series. The discharge will not be as intense as with using the two photo batteries, but it will work quite well.

Transformer T1 is a high-voltage auto-transformer. T1 has three wires coming out of it, two enamel-coated wires, and one green insulated wire from the center (Fig. 3-3). The green wire is the high-voltage wire that connects to the discharge plate. The two enamel wires are the "primary wires" that get connected to the switch (SW1) and capacitor (C1). It doesn't matter which one of the enamel wires is connected to the switch and which one to the capacitor; either way, the circuit will function properly.

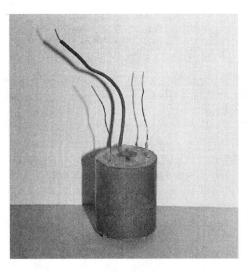

3-3 Photo of HV transformer.

Capacitor C1 in the drawing, is actually made up of four small capacitors wired in parallel (Fig. 3-2). Toggle switch SW1 is an SPDT (single-pole double-throw switch) *momentary contact*. The switch has three contact pins on its bottom to solder wires (Fig. 3-4). The switch is an important piece and it must be wired in correctly to get the maximum benefit of the circuit. The advantage of this particular switch is when it is toggled it doesn't lock or stay in the other position. A spring in the switch pushes the toggle back immediately to its original position; hence the name "momentary contact." The schematic shows how the switch appears in its resting state. In the resting state, the batteries are disconnected from the circuit; this preserves the shelf life of the batteries. Also, the discharge path from the capacitors to the transformer is closed. This prevents a potential shock hazard from being stored in the capacitors, later to be unleashed on an unsuspecting experimenter.

When the switch is toggled in the other position, the discharge path is opened and the batteries are connected. The batteries quickly charge capacitor C1. When the switch is released, the batteries are disconnected and the discharge path is closed. As soon as the discharge path closes, the capacitor discharges through the transformer creating a high-voltage pulse. It isn't necessary to hold the switch in the other position to charge the capacitor. It will charge faster than you can release the switch. Essen-

SW1

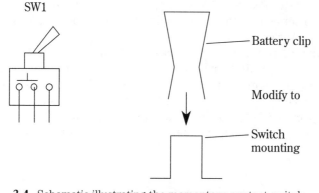

Battery clip

Modify to

Switch mounting

3-4 Schematic illustrating the momentary-contact switch used in the circuit and mounting bracket for switch.

tially, you are flicking the switch in the other position and letting the switch fall back into its resting position. This allows you to make multiple discharges very quickly to expose the film.

Remember the resting position of the switch is important. It disconnects the batteries from the circuit so that the unit can be stored without depleting the batteries. Second, the discharge path from the capacitors is closed, preventing any shock hazard from the capacitor and HV transformer.

To mount the switch to the board, I used a metal battery clip (see the parts list). The clip is bent into a U shape. The center hole in the clip is enlarged to fit switch SW1. A hole is made on each ear of the modified clip to secure it to the board with two wood screws. The switch is secured to the clip, then the assembly is secured to the board using wood screws.

Exposure plate

The discharge plate is made from a 4"-x–6" copper-clad board. The board that I used is single sided, meaning it has copper on just one side. The green wire from T1 is soldered to the corner on the copper side of the plate. The copper side of the plate is placed face up and is glued to the wood board. After the glue dries, the plate is then covered with a plastic sheet that extends at least 1" past the exposure plate sides. The plastic sheet is secured by taping or gluing it in place. Remember, the plastic sheet should completely cover the discharge plate with a minimum of a 1" border past its edges on all sides. The thickness of the plastic I used is approximately 0.005" thick; however, this thickness isn't critical—anything close to this thickness will be OK. Plastic sheets like this are readily available from most art or drafting supply stores.

In the prototype, I used a transparent sheet of plastic to cover the discharge plate to show as much detail as possible. However, using transparent plastic isn't required—any plastic sheet, transparent or opaque, can be used.

Testing and finishing construction

When you have completed the circuit, test it before mounting everything on the board. To test the circuit, attach a wire to point A (shown on the schematic) and

place the other end of the wire about ¼" away from the discharge plate (note: the discharge plate shouldn't have the plastic sheet covering it during this test) or the uninsulated end of the green high-voltage wire. Every time you flick switch SW1, you should see a spark jump across the ¼" distance.

When the circuit checks out properly, mount the components on the board using glue or epoxy. You can then coat any exposed wires with a plastic spray to insulate them (try No-Arc spray, available at local Radio Shack store). If you should do this operation, you might want to leave some wire bare at point A—see the exposures section for explanation.

B/W film

I have successfully used Kodalith 2556 ortho film type 3. The film is available in 4"-×–5" sheet form. This is a high contrast, black-and-white graphics-art film. This film's light handling requirements are much less stringent than for color film. You can use a red photographic safelight when handling, shooting Kirlian photographs and developing this film. If a photographic safelight isn't readily available, you might try using a red neon lamp, a red LED or wrap red acetate plastic over a dim 4-W bulb.

The trade-off for ease of use are less-spectacular Kirlian photographs than you would attain with color sheet film. For complete developing instructions for the B/W film, see chapter 4.

I advise all beginners to first work with 4"-×-5" B/W sheet film. The ortho film is less expensive than color film. So, making mistakes in the process of learning isn't as costly. It is much more convenient to work with and you can see what you are doing when you work under a red safelight that doesn't fog the film. You will find that shooting Kirlian photographs using a red safelight is a big advantage. When you first start working with Kirlian photography, using a high-voltage power supply in complete darkness can be a pretty daunting task. So, it is a good idea to acquire some experience with black-and-white film before proceeding on to color work.

Another advantage of B/W film is the simplicity of developing it. The developing chemistry is fast, simple, and forgiving. B/W film only requires two developing chemicals: *developer* and *fixer*. A *stop bath* is usually used in between developing and fixing to preserve the fixer solution, but isn't absolutely necessary. The ease in developing the film makes it possible to develop your 4"-×-5" film right after exposing it.

In using this B/W film with a safelight, you'll quickly gain experience setting up and shooting Kirlian photographs. In fact, the experience you could gather in one session would take another person shooting color film weeks to acquire. The reason for this is the almost instant feedback you acquire by developing the film right after exposing it. Someone who starts by shooting color will have to wait to get the film developed to see exactly what they have accomplished. They have to wait to see if the object had been set up properly on the film. Or by the time they see the pictures, they could forget exactly how they had made the set-up or set the exposure times used in any particular picture.

I hope this convinces you to start with B/W film. This learning step can save you considerable money and aggravation. For complete developing instructions for B/W

film, see chapter 4. After you gained some experience shooting Kirlian photographs, you will probably want to work with color film to get more dramatic pictures.

Color film: daylight or tungsten balanced

Color film requires exposures to be made in total darkness. This can be a problem. I sometimes fudge a little and let a small amount of light in, just enough to see what I'm doing. Most of the time it doesn't fog out the picture. I do get a green or red background, depending upon the color of the safelight I am using at the time. In any case, give your eyes a minute or two to become accustomed to the darkness before allowing any light in. You might be surprised by how little light you need to work.

Both tungsten-balanced and daylight film give striking color transparencies. The tungsten-balanced film usually produces colors ranging in the yellows, oranges, and reds. Daylight film colors range mostly in the greens and blues.

Exposures

Depending upon what you are photographing determines whether or not the object should be grounded. *Caution: If you are photographing a living subject, such as yourself or a pet, under no circumstance should that subject be grounded or be allowed to touch a ground during exposure. This will lead to a nasty shock.* If you are photographing an inanimate object (such as a leaf, coin, keys, etc.), then connect a ground to the object. By grounding the object, you will get a better corona discharge from the object. You can use a natural ground by connecting a wire to an earth ground, such as a cold water pipe, then to the object you are photographing. Or you might use a circuit ground by connecting a wire from point A (Fig. 3-1), to the object being photographed. To do this as easily as possible, use a jumper wire with an alligator clip on each end (see the parts list).

Figure 3-5 illustrates the overview of making an exposure. In some cases, you might put a flat sheet of glass or plastic on top of the object to make sure it lays down

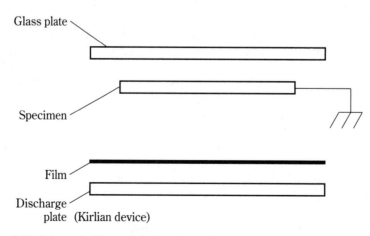

3-5 Schematic illustrating placement of materials to make a Kirlian photograph.

flat on the film and exposure plate. C-1 and C-2 illustrate two 4"-x-5" transparencies shot using this device. C-2 is a leaf and C-1 is the top of branch from a small bush.

Whether you're working with B/W or color film, place the film emulsion side up on the exposure plate. Place the object you are photographing on top of the film. If the object is inanimate, connect the ground wire to it. Flick switch SW1 about 10 to 20 times. Each time you flick the switch, you should see a discharge between the object and the discharge plate. This is what is being recorded on the film. Exposure is determined by trial and error and your technique should be adjusted accordingly.

Figures 3-6 and 3-7 are Kirlian photographs of a leaf and two coins made using B/W paper on the device. The leaf was given 20 pulses and the coins were given 10 pulses each. Notice that the pictures are in fact negatives. These paper negatives can easily be printed to make positive prints. The entire procedure for developing and printing B/W paper and film is outlined in chapter 4.

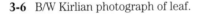

3-6 B/W Kirlian photograph of leaf.

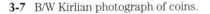

3-7 B/W Kirlian photograph of coins.

Figure 3-8 is a Kirlian photograph of a brass holiday ornament. Many metallic objects make interesting photographs, such as gears, paper clips, coins, keys, etc. Working with metal objects is a primer for learning about nondestructive testing. In nondestructive testing, you attempt to find flaws or fatigue in an object that would cause it to fail prematurely. This type of work is applicable to the aerospace, military, and nuclear industries.

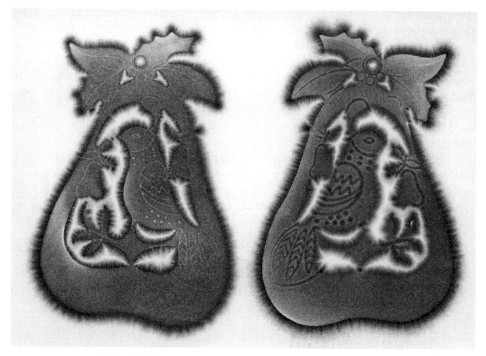

3-8 B/W Kirlian photograph of brass holiday ornament.

Shooting models and live subjects

This particular device is a little weak to shoot fingertip coronas. If you try anyway, I advise using B/W film instead of B/W paper (thinner dielectric). In addition, remove the standard dielectric you have on the exposure plate and let the B/W film act as the dielectric between the subject and the exposure plate. In Fig. 3-9, you can see a typical set-up to shoot a fingertip corona. Notice the absence of a ground! The reason you don't need a ground is the body's capacitance is sufficient to cause a discharge.

If you try to photograph your own fingertip corona while operating this device, I advise you to either insulate the switch or wear a glove on the hand operating the

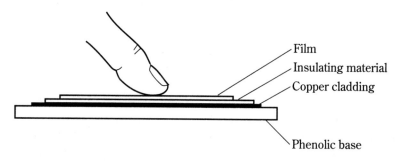

Film
Insulating material
Copper cladding

Phenolic base

3-9 Illustration showing cross section of photographing a fingertip.

switch. This will prevent a spark from jumping from the switch to your hand and giving you a shock.

Safety first

When you are photographing a live subject (human or animal), under no circumstances should that subject be allowed to touch a ground while being photographed. Touching a ground while being photographed will result in a nasty electric shock for your subject. The three Kirlian devices outlined in this book generated inductive, high voltage, low current electric power. Under normal circumstances, the high-voltage low-current electricity is not considered to be lethal to healthy individuals. However, this is no excuse to develop less-than-ideal safety conditions. In addition to never grounding a subject, never photograph anyone who has a heart problem or a pacemaker without their primary care physician's permission.

Grounding of the object, when appropriate, is a fundamental aspect of Kirlian photography. Because of this, I outline three basic methods of grounding objects and specimens. References in the balance of the book in reference to grounding will be referred to one of the three basic methods: type 1, type 2, and type 3. As you gather experience, you will develop methods for photographing particular objects. The method you develop will probably be a derivative of one of the three methods described.

Type-1 grounding

The *type-1 ground* is the simplest (Fig. 3-10), and is probably used most often. The object being photographed is connected to a ground. This provides a vivid corona discharge from the object.

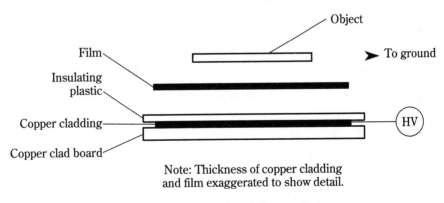

Note: Thickness of copper cladding and film exaggerated to show detail.

3-10 Illustration of Type-1 grounding.

This type of grounding is appropriate when photographing a rigid conductive object, such as a coin. To photograph a "flexible" object (such as a leaf), check to see if the leaf lays flat on the exposure plate. If it doesn't and if no corrective steps are taken, the resulting photographs will show an incomplete leaf.

The simplest solution is to connect the ground to the leaf, then to lay something on top that will force it to lay flat on the film. A piece of glass or plastic works well and also allows you to see the corona discharge.

Type-2 grounding

Type-2 grounding uses an insulated ground plate with a hole in the insulation. The hole allows the ground to make contact with the object (Figs. 3-11 and 3-12). Sometimes a part of the object is slipped underneath the insulating plastic through the hole.

Type II B

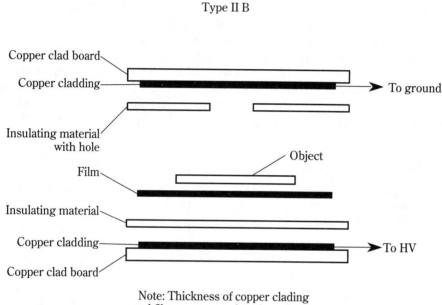

Note: Thickness of copper clading and film exaggerated to show detail.

3-11 Cross section of Type-II grounding.

Type-3 grounding

In *type-3 grounding*, the object floats between the HV plate and a ground plate (Fig. 3-13). Spacers are sometimes used to prevent a plate from lying directly on the object. Adjusting the air gap between the plates creates different effects. In most cases, it provides a rich field background.

If the ground plate is connected to the electrical ground of the Kirlian circuit, you then have an additional option of connecting the object to a natural earth ground.

Parts list for Kirlian device #1

TR1	High-voltage transformer	$17.95
HR	0.002-μF 200-V capacitors (quantity 4)	$2.00 each

SW1 Momentary-contact switch, SPDT — $3.50
Discharge plate 4"-×-6" copper-clad board — $2.50
Battery snap-on clips (quantity 2) — $1.00 each
Battery holder (for switch mounting) — $1.00
Plastic sheet — $1.00
Alligator clip and hook-up wire, 6" long — $1.00
Misc. Photo batteries and wood board

Available from:

Images Company
P.O. Box 140742
Staten Island, NY 10314
(718) 698-8305

Shipping add $5.00
NY state residents add 8.25% sales tax

Type II A

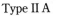

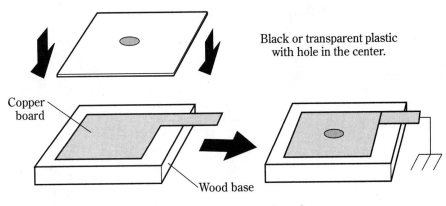

Black or transparent plastic
with hole in the center.

Copper board

Wood base

3-12 Making Type-II grounding plate.

Type III

Note: Thickness of copper cladding
and film exaggerated to show detail.

3-13 Cross section of Type-III grounding.

4

Film types and manipulations

Film is an important consideration and variable in Kirlian photography. The more you know about the types of films available and their particular characteristics, the better your decisions will be to utilize film to its best advantage.

Development chemistry and times used to develop the film after exposure is another controllable variable. These variables only need to be considered extensively if you are attempting serious scientific investigation. Then, it is necessary that all variables be recorded and/or controlled. For most work with Kirlian photography standard processing is fine.

Storage and care of films

The first thing to consider is the storage and care of film. All photographic films, aside from being sensitive to light, are also sensitive to high temperature and humidity.

To preserve film, store it all in a cool, dry place. If you store film in a refrigerator, remove the film ahead of time to allow it to reach room temperature. This permits time for any condensation, which could make an impact on the image, to evaporate. When using 4"-×-5" sheet film, it is not a good idea to return a partially used pack of sheet film to the refrigerator without first sealing it. This doesn't have to be anything complex; a plastic self-sealing bag (to place the film box in) would do the trick.

If you store your film in a refrigerator and are pursuing Kirlian photography for scientific research, the film must reach laboratory temperature before using it. The reason being that an object placed on a cold emulsion surface would have a distortion of the discharge corona. This is as a result of a change in conductivity of cold film and condensation of moisture on the film. Exactly how long you should wait for the film to reach laboratory room temperature depends upon the storage temperature. It can be anywhere from 30 minutes to 2 hours.

If, however, you are photographing special effects, by all means use cold film; this will add a measure of randomness and chaos to the discharge corona that cannot be easily replicated.

Spectral response of the human eye

The eye's sensitivity to the wavelength of light is illustrated in Fig. 4-1. From this, you can see that yellow-green appears the brightest, red and blue next, and the least sensitive are ultraviolet and near infrared. The spectral response of standard color films is narrow in comparison.

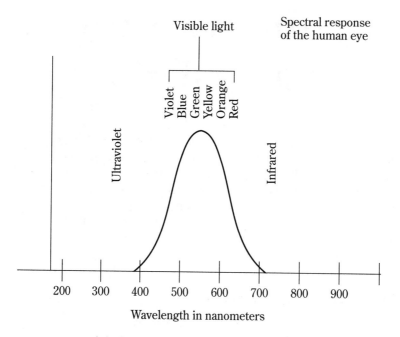

4-1 Spectral response of the human eye.

Color temperature

Color films are manufactured in two color temperature ranges: tungsten balanced and daylight. In photography, light sources are rated by their *color temperature*. The temperature of the light source determines not only the spectrum of light emitted, but also the percentage of light emitted at various frequencies. For instance, if you examine the spectrum of an incandescent lamp, you would find that it emits far more light in the infrared-red portion of the spectrum than in the blue-ultraviolet portion. Films are therefore manufactured for color temperatures to compensate and balance the sensitivity of the film to the different light sources to achieve good color rendition of the scene being photographed.

Tungsten film is balanced to a color temperature of 3200 degrees Kelvin. Because incandescent lighting (tungsten filament) emits far more light in the red por-

tion of the spectrum, tungsten-balanced film is made with increased sensitivity to blue light. If tungsten film is used with daylight lighting, the resulting pictures will have a blue tint.

Daylight film is balanced to a color temperature of 5400 degrees Kelvin. Daylight film has its red light layer made more sensitive than tungsten film. If daylight film is used for indoor picture taking under incandescent lighting, the resulting pictures would have an orange tint.

Color transparency film

Color transparency 4"-×-5" sheet film provides the most colorful and impressive Kirlian photographs. The difference between transparency film and standard color film is that the transparency film gives you a positive image. Standard color film produces a color negative that is used for printing positive images (pictures) on paper.

The direct positive image from transparency film means that the film itself yields a positive image. This is what you receive when you shoot slide film. The slides are made from the film that was shot in camera. Because the 4"-×-5" sheet film yields large transparency images, I always used color transparency film when shooting color.

Color transparency sheet film is available in either daylight (Kodak 6117) or tungsten-balanced (Kodak 6118) varieties. The sheet film sizes available are 4"×5" and 8"×10". The colors produced by the corona discharge in these films go through the entire spectrum of visible light: reds, greens, blues, and whites. The spectral sensitivity of 6117 and 6118 film is shown in Figs. 4-2 and 4-3.

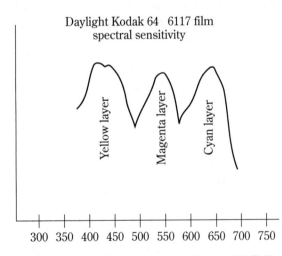

4-2 Spectral sensitivity of daylight (Kodak 6117) film.

Much has been written about the color of auras and the corona discharge. Unfortunately, these color tips do not really relate to the colors generated by the discharge corona. The discharge, is predominately blue-violet. If the film was recording the color accurately, most of the discharge would be of this color.

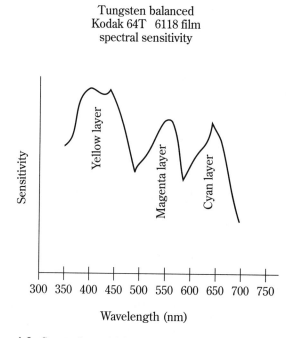

Tungsten balanced
Kodak 64T 6118 film
spectral sensitivity

4-3 Spectral sensitivity of tungsten-balanced (Kodak 6118) film.

Many Kirlian photographs show a whole range of colors, including reds, greens, blues, and white, however. Where are these other colors coming from?

To answer this question, you must examine the structure of color film. Color films are made with three separate silver halide layers. Each layer is designed to respond to a specific color of light, one for red, one for green and one for blue (Fig. 4-4). This arrangement works very well when exposing film to light in a standard camera. The colors in the image projected onto the film plane are accurately recorded in the film layers.

With Kirlian photography, the electrical discharge generates light by photoionization of nitrogen gas. This light contains a high component of UV light. If the film on top of the exposure plate buckles slightly, it creates an air gap where photoionization can occur. The buckling can occur from too much pressure or uneven pressure from the object placed on top the film. The UV light created in the air gap can activate the silver halide crystals from the backside of the film and form a red latent image in the back layers, regardless of the color of the discharge.

In addition, during long exposures, the electrical discharge will gradually expose the different film layers (Fig. 4-5). The UV light from the corona discharge activates the silver halide crystals that form a latent image in the layers.

Tungsten-balanced film, when used in direct contact Kirlian photography, usually produces colors ranging in the yellows, oranges, and reds. Daylight film colors range mostly in the greens and blues.

Color film structure

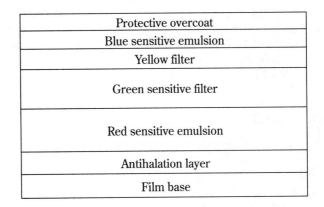

| Protective overcoat |
| Blue sensitive emulsion |
| Yellow filter |
| Green sensitive filter |
| Red sensitive emulsion |
| Antihalation layer |
| Film base |

4-4 Cross section of color film structure.

4-5 Illustration of corona discharge location and its impact on exposing film.

It is quite possible that the colors produced by Kirlian photography can in the future provide more information. However, many of the electrical parameters must be standardized first in conjunction with a standardized film before this can be accomplished.

Daylight Kirlian photography

The Images Company sells individually wrapped color transparency sheet film that is packed in light-tight envelopes. Although the envelopes are light-tight, Images recommends working with the film only under dim or safelight conditions. The film pack's envelopes are used like standard sheet film. You might want to increase the

exposure time by 25% (again, this will have to be determined by trial and error). After the film has been exposed, it is placed into another light-tight envelope, then taken to a photolab for development.

There is a small loss of resolution in the fine details of the object you are photographing when using this packaged film. You must weigh the advantages of working under a safelight safely with less resolution, as compared to working in complete darkness at higher resolution.

B/W sheet film

B/W ortho sheet film is an excellent medium for beginners, as well as for serious researchers. The spectral sensitivity of the film is illustrated in Fig. 4-6. As you can see, ortho film is quite sensitive to ultraviolet light. Because UV light is the frequency of light predominantly emitted by the corona discharge, this is an excellent research film. The film is not sensitive to red light, which allows you to work under a red safelight while shooting Kirlian photographs.

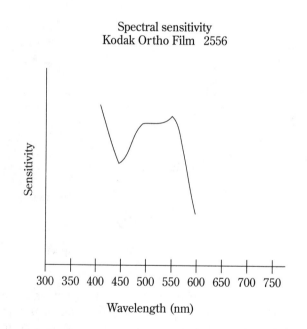

4-6 Spectral sensitivity of ortho (Kodak 2556) film.

Not having to work in complete darkness makes it easier to arrange the object you are shooting, connect ground wires, and work with the high-voltage Kirlian devices in general. When you switch from this B/W film to color, you will better appreciate the ease of working with a safelight. The film is easily developed, which makes it possible to develop the film right after exposure.

Developing ortho film

Ortho film uses a two-part developer. Mix the powders with water according to the directions; one part is labeled A the other B. Equals parts of A and B are mixed together just before developing. Mix only enough developer for your session.

You need four trays to develop your film (Fig. 4-7). The trays should be large enough to hold the film you are working with. In tray 1, place the developer made from equal parts of A and B. The film goes into the developer for 45 seconds.

Tray 2 contains either water or a stop bath. The stop bath neutralizes the developer and stops development. In addition, it also prolongs the life of the fixer. Place the film in this tray for 30 seconds.

#1
Developer

#2
Stop or
water bath

#3
Fixer

#4
Optional
water hold
tray

4-7 Tray set-up for developing black and white film and paper.

Tray 3 contains a fixer solution. This fixes the image onto the film and makes the film no longer light sensitive. The film remains in this bath for 60 seconds.

Tray 4 contains water. This is an optional holding tray. The purpose is to hold all the sheets of film there until you are finished developing film. The tray is then placed in running water for five minutes or more to remove all traces of chemicals from the film.

The ortho film, when developed, contains a negative image. Follow the directions under the section "Paper negative" to make a positive contact print from this negative.

B/W paper

You can also use B/W paper to shoot Kirlian photographs. With B/W paper, there are safelights available that will not fog the paper. The spectral sensitivity of ortho paper is illustrated in Fig. 4-8. As with the ortho film, this paper allows light for you to work in your darkroom (for exposing and developing the paper). The paper is exposed in the same manner as film. The paper is placed on the exposure plate (emulsion side up) and is exposed.

The type of paper you use determines what safelight you need. If you use an RC poly-contrast Kodak B/W paper, an OC- (light amber) filtered safelight is recommended. You will probably get away with using the same red safelight that's used with the ortho film. In a pinch, try a 4-W red bulb or red cellophane wrapped around a standard 4-W bulb.

Spectral sensitivity
Ortho sensitive paper

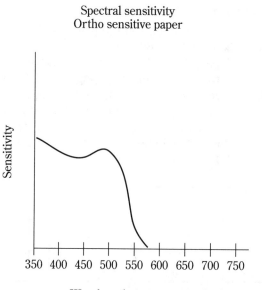
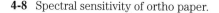

350 400 450 500 550 600 650 700 750

Wavelengths nanometers (nm)

4-8 Spectral sensitivity of ortho paper.

Simple paper development

If you are working with paper, you can develop as well as expose the paper with the safelight on. You need four trays large enough to hold the paper you are using (Fig. 4-7). The temperature required for the chemicals is very forgiving; room temperature is fine and anything between 65 and 80 degrees F will do.

Tray 1 contains a developer. You can use just about any development. Mix it according to directions on the package. Most developers require about 2 minutes.

You can gauge your exposure by how the picture looks after development. If the paper has a light or faded image, it is underexposed, meaning it needs to have been exposed longer. If the paper turns very dark or completely black, it is overexposed—too much light cut the exposure time in the camera.

You can compensate for underexposures or overexposures somewhat by varying the time in the developer. For an underexposed paper, keep it in the developer another 2 minutes or until it reaches a density you like. After about four minutes, the developer isn't going to do much more. With overexposed paper, if the paper is turning black, remove it immediately and put it into the stop bath; this might save the print. Proceed with the balance of development. Although you might salvage some prints this way, it's a good idea to learn from the experience; vary your exposure time accordingly.

Tray 2 contains a stop bath. This, as the name implies, stops further development. You can buy a commercial stop bath or use plain water. A stop bath is better, and it helps prevent the fixer from being contaminated with developer solution. The 30-second time is a minimum; you could leave the print in the stop bath longer.

Tray 3 contains the fixer. This fixes the image on the paper so that it is no longer light sensitive. After the paper has been in the fixer for 2 minutes, you can turn on a regular light. The two-minute time is a minimum; you could leave the print in the fixer for a much longer time.

Tray 4 contains water; it is a holding tray. It holds the prints in water until you can bring it to running water. After you are finished with all the prints you are developing, place the tray under running water for 10 minutes or so. This removes the fixer from the paper. If the fixer isn't removed, it will eventually turn the print brown and fade the image.

The paper negative

If you just finished processing a picture from your camera, you might be surprised to find that it contains a negative image. This is called a *paper negative*. It can be used in the same manner as a film negative. You might be a little wary at this point wondering how good a picture you can get from a paper negative. I know I was, but rest assured. The results are very good. You will not be able to see the difference between a picture that was made from a paper negative and one that was made from a film negative.

After processing the paper, you can immediately make a contact print before you store the developing chemicals. If the paper negative you just developed is still wet, that's OK. Under safelight illumination, remove a fresh sheet of paper from its box. Wet this paper with water. Place the papers together, emulsion to emulsion, with the negative on top. Put the papers down on a flat surface. Turn on the room light for 1 second. Now, develop the fresh sheet of paper and you will have a positive print. Figures 4-9 and 4-10 show positive and negative film images made in the same manner as paper.

You could also do this with dry paper. If you want to try it, put a clean piece of glass on top of the sandwich to hold the papers flat. Always make sure the negative is on top or you won't get a picture. You can vary the 1-second exposure, depending on if the positive is underexposed or overexposed.

4-9 Photo of a B/W paper negative.

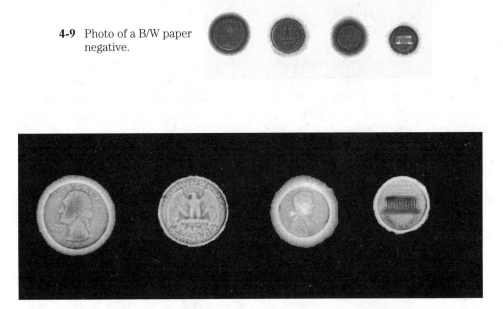

4-10 Photo of a B/W paper positive from a paper negative.

35-mm film

To use a 35-mm camera, you must have built or purchased a transparent electrode. You can use either slide or print film in the camera. The only stipulation is to use the fastest film available. The spectral sensitivity of Kodak ISO 1600 film is shown in Fig. 4-11.

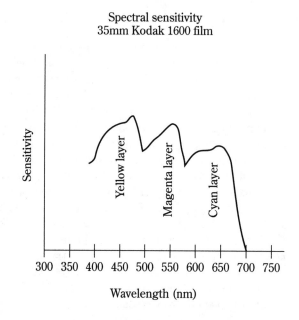

Spectral sensitivity
35mm Kodak 1600 film

Each peak represents the spectral
sensitivity of an individual film layer.

4-11 Spectral sensitivity of a Kodak ISO 1600 color print film.

One hint that you might wish to follow is to start each roll of film with a few conventional pictures. This provides the photolab with proper frame markings for their print machine. When bringing the film for development tell the clerk to print all pictures. If you don't tell them this, they might assume that your Kirlian pictures are some sort of weird errors or bad pictures and not print them.

Instant Kirlian pictures using Polaroid 600 film

Most of us like to see the pictures we shot as soon as possible. More so for Kirlian photographers because it helps to gauge the exposure times or it lets you know if there were any errors in setting up or grounding the object. Although most of these questions are answered when using black and white material under a safelight, when using color film, you are pretty much working in the dark (pun intended). There is help though by using Polaroid film. The set-up described here uses Polaroid 600 film with an inexpensive camera to get instant color pictures.

The equipment you need besides the Kirlian device is minimal: an inexpensive camera that uses Polaroid 600 film and a package of 600 film (Fig. 4-12). Each 600 film pack contains 10 pieces of 600 film. The number 600 refers to the speed of the film. So, Polaroid 600 film is rated as ISO 600, pretty fast. This is an integral film, meaning that there is no peeling away of a negative from the positive print. The 600 film pack is protected with a cardboard cover (Fig. 4-13). When the film package is loaded into the camera and the camera's film compartment is closed, the protective cardboard is automatically ejected (Figs. 4-14 and 4-15).

The procedure to make a Kirlian print is as follows. In complete darkness, open the camera's film compartment. Remove the entire film package. Slide the top piece of film out of the package (Fig. 4-16). The film is emulsion side up. Place the film onto the Kirlian device and make an exposure (Fig. 4-17). Put the Polaroid film back inside the film package. Now, place the film package back inside the camera. When you close the camera's film compartment, the top piece of film will be automatically

4-12 Photo of a Polaroid 600 camera and a 600 film cartridge.

4-13 Photo of a 600 film cartridge.

4-14 Loading the film cartridge into the camera.

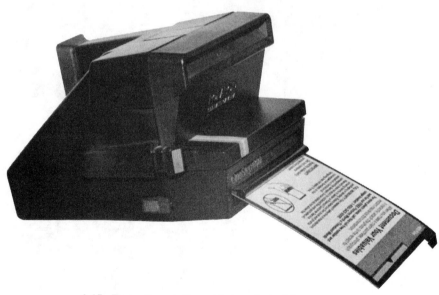

4-15 Protective cardboard being ejected from camera.

ejected, just like the protective cardboard had before (Fig. 4-18). At this point, the light-sensitive film is safely back in the closed camera, the sheet of film that was ejected is developing and is light safe, and you can turn on the room light to watch the development of your 600 print.

When the sheet of film was ejected, the developing chemistry pod (located at the front of the sheet film) was activated. The rollers squeezed the chemistry pod

4-16 In total darkness, remove one sheet of film from the cartridge.

4-17 In total darkness, place the film onto the Kirlian device and make the exposure.

(breaking it) and evenly spread the chemicals over the emulsion. In a minute or so you have a finished color Kirlian picture. Color plates 4 and 5 are examples of Polaroid Kirlian pictures using the 600 film and process described.

A few hints are in order that might help you make this process more successful. First, place whatever object you are shooting in the center of the film. The edges of the film are somewhat conductive, so if a ground wire or part of the object comes close to the edge, the high voltage will arc to the film edge, rather than form a corona discharge around your object.

The Polaroid film appears to give the most realistic color of all the films I have used. The corona discharge (aura) in the 600 film is predominantly blue-violet. The film also appears to have greater sensitivity to UV light than the human eye. A dark blue aura appears around objects that extends further than what you can see naturally.

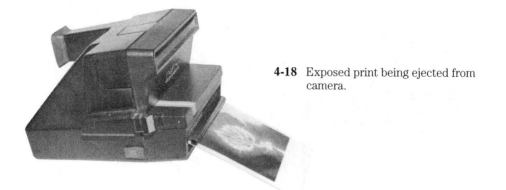

4-18 Exposed print being ejected from camera.

Polaroid transfers

This is an artistic procedure that transfers the emulsion from Polaroid film to paper. You can use types 668, 669, 59, 559, or 809 Polaroid film for wet and dry transfers. For the transfers illustrated in this book, type 669 Polaroid film was used. This film was exposed in a Vivatar instant slide printer (Fig. 4-19).

To generate slides, you can shoot slide film directly with a Kirlian device and a transparent electrode. Or you can do as I have done and reshoot my 4"-×-5" sheet film transparencies onto 35-mm slide film.

There are a number of alternate methods of getting a Kirlian image on Polaroid film for transfers , they cannot all be explored. One is to use the Polaroid 4"-×-5" film directly on the Kirlian device.

4-19 Photo of Vivatar slide printer.

The images can be transferred to a wet or dry receptor surface. The receptor surface that is most commonly used is paper. Polaroid transfers onto wet paper create a watercolor effect. Dry transfers on the other hand have sharper resolution. The basic transfer procedure is the same for both wet and dry transfers. The only difference is the condition of the receptor surface. For this example, wet paper is used as the receptor surface.

Polaroid wet transfer example

1. Obtain a high quality paper from an art supply store. Something with a high rag content will work well. As you gain experience, you might want to try other media, such as cloth and silk. However, for the first time use paper. Place the paper in a tray of water. Let it soak for 30 seconds. Remove the paper and place it on a flat dry surface. Squeegee or paper towel the surface of the wet paper to remove excess water.

 A. I used an alternate method to wet the paper. I sprayed water onto the paper. This makes the paper damp without saturating it (see Fig. 4-20).

4-20 Spraying water onto the paper.

2. Produce an image on the Polaroid film any way you wish. For this transfer, I used a Vivatar instant slide printer. I chose a slide and composed it on the slide printer. I copied the slide onto the 669 film. At this point, recheck the materials to make sure everything is set up properly. You can take as much time as you want at this point. The transfer process doesn't actually begin until you start to develop the film. The development begins when the film is pulled through its developing rollers or run through the processing system. The Vivatar slide printer will simply pull the film out to start the development. The dyes from the negative start migrating to the positive. Peeling apart the film prematurely stops the dye migration. This leaves the negative with much of the dyes. Experiment to find the best times to peel the film apart. For this demonstration, peel the film apart after 10 seconds.

3. After the film has been pulled through, wait 10 seconds and peel the film apart (Fig. 4-21), set the positive aside. Place the negative face down on the receptor sheet as quickly as possible (Fig. 4-22). If you wait too long, it will dry out the dyes. Using your hand or a roller, rub the entire negative into the paper. Wait 30 to 90 seconds, then gently peel the negative off the paper. Start at one end of the negative and pull it off in one smooth slow motion (Fig. 4-23).

4-21 After 10 seconds, peel the film apart.

A. Be aware that different film formats are held together slightly differently than the 669 film. The Polaroid 4"-x-5" sheet films have a metal clip that holds the negative and positive together. The clip area is known as the *trap end*. It traps excess chemicals. When the film is pulled through to begin developing the first step is to cut off the trap end with scissors.

4. The paper has been transformed into an original piece of art (Fig. 4-24 and C-13). The transfer image can be reworked with pencils, dyes, needles, pastels, etc.

There are many variables that you can experiment with when making transfers. The primary consideration is the type of receptor surface. You can use a large variety of papers (such as heavy bond, rice, newsprint, drafting vellum, etc.). You can also transfer to fabrics (such as cotton, denim, and silk).

Experiment with different ways of applying pressure to the negative during transfer. You can cover the negative with another piece of paper to act as a buffer. Try using rollers and squeegees to achieve even pressure across the film. Images that have black areas in them require a little more pressure in the black areas.

4-22 Place the negative onto the wet paper immediately.

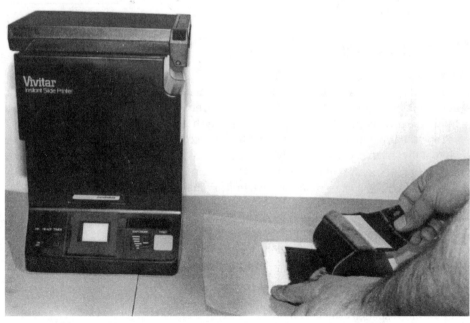

4-23 Wait 30 to 90 seconds, then gently peel the negative off of the paper.

4-24 Close-up of the dye transfer (see also C-13).

Another experimental factor is the time to wait before peeling apart the film. This can vary anywhere between 10 and 30 seconds, depending upon the film type you are using. For the 669 Polaroid film, I recommend not waiting longer than 15 seconds before peeling the film apart. Varying the time before peeling has a direct impact on the dye migration. In an early peel, the negative is left with most of the cyan dye, approximately half of the magenta layer and very small amount of yellow. This creates a cyan bias to the image. To correct this color balance, use 10 or 20cc red filtration when making your original exposure. Longer processing times allow much of the dye to migrate to the positive, leaving less dye for the transfer.

If making wet transfers, how wet the receptor surface is left is another important factor that affects image quality.

Hints and tips

There is a simple way to use color film (sheet or Polaroid) with a safelight. If you are using a red safelight, acquire a piece of green transparent plastic. If you are using a green safelight, acquire a piece of red transparent plastic. The size of the plastic should be a little larger than the exposure plate that you plan to use.

Tape the top end of the plastic sheet to your exposure plate. This forms the plastic into a flap so that you can easily slide a sheet of film underneath.

In total darkness, remove a sheet of color film from its box. Feel the corners of the film to find the corner with the nick in it. Remember that the nick identifies the emulsion side of the film. Place the nick on your top right-hand side; the emulsion side of the film is now facing you. Slide the film underneath the plastic, emulsion side up. You can now turn on your safelight.

How long you can keep your safelight on without fogging the film will depend on the color emission of your safelight and the color bandpassing of the colored transparent plastic on your exposure plate. You will notice that this technique adds the color of the transparent plastic to your final Kirlian picture. This, in itself, can be used for more special effects.

5

Kirlian claims research

The Kirlians published papers in the late 1950s and early 1960s. One paper, "Photography and Visual Observations by means of High Frequency Currents" was published in the Russian *Journal of Scientific and Applied Photography and Cinematography* in 1961. In it, the Kirlians described their experimental techniques and observations of living organisms. In this paper, the Kirlians stated," It is apparently possible to make judgments about the biological and pathological states of an organism and its organs."

This paper was translated in 1963 by the Foreign Technology Division of the Air Force and dispersed as an unclassified document. Essentially, the paper didn't generate any interest in our country.

News of Kirlian Photography reached the general population in America in the early 1970s with the publication of the book *Psychic Discoveries Behind the Iron Curtain (PDBIC)* by Sheila Ostrander and Lynn Schroeder. Paranormal researchers, psychics, and spiritualists embraced this new technology from Russia. It appeared that the Russian researchers had scientifically detected, measured, and validated what paranormal researchers and psychics had been saying for years about human bio-plasma, life force, auras, etc.

Within two years of the publication of the book *PDBIC*, many nonscientists had begun their own experimentation with Kirlian photography. What followed was a plethora of unconfirmed research, sweeping conclusions based upon inadequate experimental controls that was reported by an unskeptical media. Although much of this research might have been good natured, it scared away serious researchers from pursuing Kirlian photography as a possible research tool. And there is no doubt that there were a few con men involved in Kirlian Photography looking to cash in on an unsuspecting public.

Not all the data gathered by the nonscientific investigation is suspect; some of the data is believable. However, some of the conclusions drawn and the reasoning involved might be a misinterpretation of known physical laws.

The fact is that the acceptability of any data is based upon the ability of other scientists to repeat the experiments and achieve the same results, not whether the data fits into the existing dogma. The fact that some results fit existing physical laws does make the data palatable by the scientific community, but it doesn't eliminate the need for strict controls on the variables and proper record keeping. This is the reason that so much of this data is ignored. We can be equally formal to some of the critics of Kirlian research by stating the obvious fact that their negative "opinion" of Kirlian photography does not equal research either.

Serious research with Kirlian photography requires that many of the parameters must be either measured and/or controlled. The balance of this chapter is devoted to an overview to some of the claims made of Kirlian photography in the past.

Can Kirlian photographs show mental and physical states?

Can Kirlian photography show physiological and psychological states of subjects? Yes, it can. How can I make this statement without confirming it to you with data, listing the experimental parameters used, and showing the photographs? The conclusion is based upon sound and existing scientific data. In other words, no new phenomena is needed to be evoked to explain the results obtained. It has also been reported by a number of researchers throughout the years.

Lie detectors rely in part on *galvanic skin resistance (GSR)* of the subject. When a subject lies or has a psychological response to a question, their skin resistance drops. This is easily monitored by a GSR meter. If a Kirlian photograph would be made before and after such a response, there would be an increase in the diameter of the discharge (aura) as a result of the decrease in skin resistance. By using a transparent electrode, someone could monitor the corona discharge diameter continuously and determine the subject's psychological response. Although this would make an interesting lie detector, it would be less effective than the standard GSR meters already in use. As with a standard GSR meter, base lines would need to be established before useful information could be obtained.

Remember that the expected Kirlian response has to do with the diameter of the corona discharge, and not the color. Now let's look at a few reports from other researchers.

The October 26, 1973 issue of the *Medical World News* featured an article on Kirlian photography. The basis of the article sought to answer the question if photographs of corona discharges could become a diagnostic tool. This article was accompanied with a number of fingertip photographs taken by UCLA's Dr. Thelma Moss. The photographs were presented in a before and after sequence showing the effects of different substances on the body. The first pair of pictures showed a small corona discharge from a fingerpad (the before picture). The next photograph showed the same subject after smoking marijuana. The corona discharge had changed becoming quite large and luminous.

The next sequence of photographs illustrated the effects of alcohol. Again, the first corona picture was small and weak. After consuming 7 ounces of alcohol, the picture of the corona discharge became larger and more defined. The last picture in the sequence (after the subject consumed 14 ounces of alcohol) was larger still.

The final pair of pictures by Dr. Moss showed the effects of a psychic "faith" healer on a dialysis patient. Again, in the first picture the corona was weak and ill defined. The second photograph taken after the faith healer applied the laying on of hands showed a much brighter discharge. Dr. Moss went on to say that the corona discharge can change dramatically depending on the physical and mental conditions.

The October 26, 1973 issue of *Medical World News* also contained an article by two MDs, David Sheinkin and Michael B. Schachter, who were psychiatrists at the Rockland County Community Health Center in Pomona NY. The doctors attempted to make a controlled study to determine whether they could get the same kind of changes in the discharge pattern of their patients each time. Most of the patients these doctors worked with had psychiatric problems, such as acute schizophrenic decompensation and alcohol psychoses.

With schizophrenia patients, they found a lack of clarity in the fingerpad corona. With one particular patient, the corona was almost nonexistent. Five days of treatment with medication brought the patient's schizophrenia under control; subsequent photographs showed the finger pad corona was present with increased clarity.

The doctors also noticed corona changes in physical problems (such as pneumonia, gastroenteritis and upper respiratory infection). The patterns they observed for GI disturbances were completely different from those associated with upper respiratory or psychiatric illnesses.

Professor of Psychology Bernard I. Murstein, Ph.D., and Serge E. Hadjoliam reported in the September 1975 issue of *Human Behavior* a positive correlation between aura size and attraction. If you are attracted to another person, this will show as an increase in the diameter of the corona discharge (aura).

In 1977, Lee R. Steiner, Ph.D., wrote a book entitled *Psychic Self Healing for Psychological Problems* that was published by Prentice-Hall. Ms. Steiner correlated evenness of fingertip corona discharges to mental health. A bright even corona discharge (aura) would be obtained from someone who was mentally healthy. A broken pattern in the discharge showed a problem. An interesting thought that I had not read previously was her idea to photograph both right and left index fingers and correlate them to right and left brain functions.

In 1982, at the International Congress of Medical Physics in Hamburg, Dr. Vittoria Marangoni presented results of her study using Kirlian photography. Dr. Marangoni and her colleagues examined several hundred psychiatry patients, most of whom are schizophrenics. They found that healthy people have a complete mostly blue corona discharge from their fingertips. In a schizophrenic, however, the corona is very patchy or is nonexistent. They also noticed a structureless red coloration under the schizophrenics' fingertips.

The Army experimented with using Kirlian photography to see if it could measure the physical and mental health of military personnel and to determine their level of fatigue. The experimenters used the diameter of the corona discharge from a finger pad as a measurement. Analysis of the results produced two statistically valid conclusions. The first was that the personnel suffering physical stress (exer-

cise) produced a larger-than-test-average corona discharge at the fingertip. Second, the personnel suffering mental stress (fatigue, etc.) had corona discharges smaller in diameter than the test average.

The synopsis of the report I read did not list any of the variables that might have been controlled. However, it did raise a question if the test results could be caused by the dilation or constriction of the blood vessels. Another study was invoked. In this test, subjects were given compounds to either dilate or constrict their blood vessels. These compounds did not produce a statistic difference in the corona discharge diameter according to the report.

In general, physicists agree that mental and emotional states do influence the skin's surface chemistry and electrical impedance (ac resistance). In addition, certain organs will function at an increased rate while others will function at a decreased rate. These factors would alter the corona discharge from the subject.

To see how some of these changes affect the corona discharge, examine the factors involved. The skin resistance has been estimated at 50 kΩ to 1 MΩ, the body's capacitance at 20 to 50 pF. The body's overall resistance (impedance) to the Kirlian device's high voltage depends upon the operating frequency. The body behaves like a simple RC (resistor-capacitor) filter. Depending on the real-time RC values for an individual determines the filter's cutoff frequency. Frequencies higher than the cutoff will appear as voltage drops across the resistive (skin) elements. Frequencies below the cutoff will appear as voltages across the capacitive elements. The frequency distribution of voltages across the skin surface depends on the RC network and frequency of the Kirlian device. Varying the frequency alters the frequency distribution and hence the appearance of the Kirlian images.

Changes in the skin resistance in response to psychological and physiological factors is a well-established phenomenon. The body's capacitance is a function of the overall size and geometry and it isn't known if it changes in response to psychological or physiological factors.

The color of your aura

When using color film, the Kirlian aura takes on many different colors. Currently, however, the colors produced are unreliable. The corona discharge in the atmosphere is basically blue-violet. The imprinting of color on the film is caused by variables both mechanical and electrical. The corona discharge generates high quantities of ultraviolet light that can activate the photosensitive silver crystals in the three dye layers of the color film. The large variety of colors in Kirlian photographs are mostly artifacts and not related to the actual color of the discharge.

This can be shown in a number of ways. Start by taking a series of Kirlian photographs of a stable object, such as a coin. Keep the frequency the same and change the exposure times. You will find that the color varies in the series of pictures.

The corona discharge can be almost completely eliminated by placing an ultraviolet filter between the film and the object being photographed. The filter stops the greater part of the light of the corona discharge from exposing the film.

The aura can be varied in color by substituting a tungsten-balanced film in place of daylight film or vice versa. Substituting a transparency (slide) film in place of color print film will also yield different color auras.

As explained by Kirlian photography researcher W. Tiller of Stanford University, if the film does not lay perfectly flat on the dielectric, small air pockets form between the plate and film, which can initiate secondary ionization and expose the bottom layer of the film.

It has been my experience that Polaroid 600 film gives the most accurate Kirlian photographs of the corona discharge with very little artifacts.

There are a few cases where colors in the discharge might not be artifacts. A high sodium or salt content from sweat can induce a yellow/orange-burst characteristic of the spectral lines of sodium. Other body electrolytes in sweat (such as potassium) might have some influence on the corona discharge color.

For the most part, however, the changes in color of the photographed corona discharge have to do with the electrical parameters of the Kirlian device (frequency, voltage, and pulse modulation), physical and mechanical parameters of the exposure plate, film and object, and the type of film. Additional variables are temperature, humidity, barometric pressure, and possibly the air ionization level.

In 1976, the Advanced Research Projects Agency (ARPA) of the Department of Defense published results of Kirlian experiments it had funded in the October 15, 1976 issue of *Science*.

The researchers, John Pehek, Harry Kyler, and David Faust reported that moisture appears to be the main variable that determines color and form. During exposure, moisture is transferred from the subject to the surface of the film. This moisture causes an altered discharge pattern.

Disease

I have read reports that Kirlian photographs have shown marked differences in the aura of cancer cells as compared to normal cells. This isn't as farfetched as it might first appear. If you photograph normal liver cells in a petri dish, I'm sure that it would photograph differently than cancerous liver cells in a petri dish. This can easily be explained by differences in conductivity of the cell cultures.

The real question is whether Kirlian photography can be used as a non-invasive diagnostic tool in medicine. The original reports from the Soviet Union clearly stated that there were noticeable changes in the corona discharge pattern and that these changes could forecast or provide an early diagnosis of disease, especially cancer. Medical research has followed up on these reports and they appear to be accurate, although they might be accurate for different reasons than what was supposed 20 years ago (see chapter 8).

It has been stated by a few researchers that although illnesses clearly show up as distortions in the discharge patterns, the patterns created must be accurately deciphered. In one study, the fingertip coronas of 120 adults were photographed. Out of this sample, 20% had a corona discharge that was statistically below the average. From this 20%, it was determined that 50% suffered some medical problem. So, the headlines of this study look good, but the study is flawed. No report was made on the health of the 80% whose corona discharge diameter was not reduced. In addition, there was no follow-up on the individuals whose corona discharge was decreased and who had no ascertainable medical problem. Naturally, it would have been quite interesting to see what percentage might have developed a medical problem within a short time span.

Leonard Konikiewicz, director of medical photography at Polyclinic Medical Center in Harrisburg, PA reported in the April 1978 *Medical Tribune* that Kirlian photography successfully detected cystic fibrosis carriers (see chapter 8).

The corona discharge of cystic fibrosis carriers shows an uneven, broken, or clumped corona, rather than an even, round one. In a "blind" study, the Kirlian photography accurately identified 12 out of the 13 clinically verified carriers and 13 of 14 noncarriers.

Another medical researcher, Dr. Ion Dumitrescu uses the Kirlian technique to help make medical diagnosis. Dr. Dumitrescu is a Rumanian medical doctor with a degree in electronics. According to Dr. Dumitrescu, healthy tissue emits a dark image. Unhealthy tissue emits a bright image or corona pattern. Dr. Dumitrescu performed a mass screening of 6000 chemical workers. He found malignant tumors in 47 workers. Conventional tests confirmed 41 patients had malignant tumors. He feels conventional testing will confirm the other six workers as soon as their tumors become large enough to be detected by conventional means.

In order to do serious medical research, a researcher must quantify factors, such as moisture levels on the skin, along with taking and recording such electrical measurements as EEG, GSR, and EMG. By doing so, you can establish a baseline from which research can be launched. As it stands now, it is not possible or it is very difficult in the least to compare two Kirlian photographs to ascertain accurate information.

Nutritional value of food

Some researchers have tried to use Kirlian photography to determine the nutritional value of food. Although this is a worthwhile pursuit, the data I have seen so far, in my opinion, lacks any scientific validity.

Typically, fresh vegetables are photographed and compared to the same vegetable after cooking. The methods of cooking are sometimes categorized (such as boiling, steaming, stir fried, etc.) in an attempt to compare and show the more harmful methods of cooking. The Kirlian photographs of the raw produce is more sparkling and defined; the cooked vegetable is usually a mushy blob.

The difference in the photographs can be traced to the degradation of the cellular tissue caused by cooking and not its nutritional value. Remember, anything that changes an object's resistance will show up as a distinct difference in a Kirlian photograph.

Traditional scientific methods already have determined that cooking does in fact reduce the vitamin content. So, for Kirlian researchers to say that cooking reduces the nutritional value of foods is simply restating the obvious.

The question remains: can Kirlian photography be used to determine the nutritional value of foods? Perhaps. Because someone wishes to use Kirlian photography to make a determination doesn't mean they should abandon traditional scientific methods. Traditional scientific methods must be used to calibrate and test the research. One way to start would be to determine the vitamin content of one raw vegetable. For instance, is there or can you find the right frequency, voltage, time, and pressure to observe the vitamin A or sugar content of a carrot?

A quick, reliable, and noninvasive method of testing produce, whether for vitamin content or taste, would be quickly welcomed in the produce industry.

Bio-plasma

Another theory or aspect of Kirlian photography is the possibility of photographing *bio-plasma*. *Bio-plasma* is a term used to describe a material that forms a duplicate of the physical body. This energy matrix encompasses and surrounds all living things: plants, animals, and humans.

This energy body has been claimed to be the source of historic and religious artifacts, such as pictures showing an aura around saints and the ancient yoga's prana energy.

More recently (in 1908), Walter Kilner of St. Thomas Hospital in London developed goggles that he believed helped to see the aura around the human body. Kilner stated the aura was a cloud of radiation extending out about 6-8 inches. The aura shows distinct colors relating to fatigue, disease or mood. He claimed that by observing the aura he could see the health of the individual and was of a great help to him in medical diagnosis. The goggles are made using a coal tar dicyanin dye on glass. The dye blocks most visible light while allowing the shorter wavelength ultraviolet light through. People have to train themselves with the goggles to see the aura. I have never used aura goggles made with dicyanin dye, so I can't comment on them. However, "aura goggles" are available through Mankind Research Foundation, see Suppliers Index (Ref. Kilner W., *The Human Aura*, University Books, New Hyde Park, NY, 1965).

Looking back toward Russian researchers, V. S. Grinschenko, V. M. Inyushin, B. A. Dombrovsky, V. H. Kirlian, G. A Seriev, and others developed the bioplasma theory. Inyushin claims that the bioluminescence revealed in Kirlian photography is not only caused by the electrical discharge. Instead, he feels that the bio-plasma is made up of freely charged particles that exist in organized patterns and create uniformed energy networks and pathways. However, the nature of these freely charged particles is such that the bio-plasma energy field is unstable as a result of external magnetic fields, temperature changes and other environmental influences (V. M. Inyushin, *The Biological Essence of Kirlian Effect*, Alma Alta, Kazakh State University, USSR, 1968).

Note: do not confuse *bioplasma* with *plasma*, as defined in physics. The Russians, when talking about bioplasma, are describing a new form of energy plasma.

Chapter 7 covers the work of Dr. Robert Becker, who has shown a correlation between solar magnetic storms and a human psycho-physiological response. Although this information fits into the theory by Inyushin, Dr. Becker did not feel compelled to evoke a bio-plasmic theory to explain this influence on human behavior.

Russian researchers feel that the bioplasma is replenished by the oxygen we breathe. Breathing charges the bioplasmic body. They relate this historically to the Indian Yoga philosophy, which explains that energy or "Prana" is related to proper breathing. They also relate this to research that shows the positive effects in humans of negative-charged ionized air.

Plants and leaves

The Kirlians claimed that disease in plants changes the corona discharge of plants before any physical manifestations of the disease becomes apparent. In April 1977, *The Biological Photography Association* (Vol. 45 Num. 2) published an article by Carl Boxer and Michael Paulson. In the article, these researchers published their results when testing the Kirlian plant theory.

The researchers inoculated healthy Mexican lime plants with tristeza virus. Physically, it was not possible to identify which leaf came from the healthy plant or diseased plant, they both looked the same. But, when Kirlian pictures were taken of the leaves, the diseased leaf did not show the entire vein structure of the leaf. The healthy leaves in the Kirlian photographs did show the entire vein structure.

Similar results were obtained by conducting the same experiment on pineapple citrus leaves. The researchers were impressed with their results and hoped to carry their research further.

Phantom leaf

The phantom leaf is the most interesting and spectacular phenomenon in Kirlian photography. Here, a small section of a leaf is removed, typically 5 to 10%, before photographing the leaf in a Kirlian device. In a few of the subsequent photographs, the missing section of the leaf also appears. This phenomenon is rare; it is estimated that only 5% of the photographs will show the phantom leaf phenomenon.

Russian researcher Adamenko as well as other Russian researchers claim to have photographed the phantom leaf on more than one occasion. Because I feel this is the most interesting and novel aspect of Kirlian photography, I have decided to devote one chapter of this book recording my search for the phantom leaf. If this phenomenon could be validated, it would prove that there is some form of bio-plasma. All additional information on the phantom leaf phenomenon is found in chapter 10.

Superconductive plasma

The Biochemistry Laboratory, Naval Air Development Center at Warminster, Pennsylvania, studied the use of Kirlian photography to measure "diffused relativistic superconductive plasma." The scientist performing the research was Freeman W. Cope. It had been theorized that all matter (living and nonliving) contains and is surrounded by diffused clouds of matter-energy (superconductive plasma). For relativistic reasons, many properties of the plasma cannot be measured. However, one method of measurement might be the corona arc formation in Kirlian photography. Freeman Cope published several articles on this topic before his death. Unfortunately, with his death, research in this area ended.

Morphogenetic fields

A question that still remains unanswered in biology is: how do cells self-organize and form into organs and eventually a complete organism? When a single-cell organism

(such as an amoeba) divides, you just get more amoebas. A higher multi-cellular organism (such as homo-sapiens) is much more complex. By looking at a fertilized egg, you can see rapid cell division, then organization. What you can't see is how each cell determines which particular cell it will be or will become in the organism. For instance, how does a heart cell determine that it will be a heart cell and then how do all the cells that will make up the heart determine their position and function within the heart muscle? Extrapolate this for each cell in the body, the nerve cells that make up the brain and the nervous system, the bone cells that form a skeleton, the circulatory system, the glands, the organs, the eyes, the hands, and the feet—all interwoven in perfect harmony to create a living organism.

Embryonic development is a complex organization. In the 1930s, a theory was put forth by Paul Weiss called *morphogenesis*. This theory maintains that a field comes to exist in a fertilized egg that controls and molds the dividing cells into a developing embryo. As the embryo grows, so does the field, which keeps a step ahead and directs the continued growth.

The morphogenetic field can also be used to explain major and minor regeneration. *Major regeneration* is defined as limb or body regeneration in a salamander and planarian. *Minor regeneration* is defined as the healing of a cut or scrape to the skin.

With the advent of Kirlian photography, it (more specifically the phantom leaf) was believed that the Kirlian aura might be representative of a morphogenetic field.

This idea received a serious blow when geneticists most recently have been finding bits of DNA, called the *homeobox* on numerous species. The homeobox appears to be a basic genetic switch that turns on other genes, which directs the sequence of embryonic cells into structures. However, the morphogenetic field isn't completely dead; the actual construction of the structures (organs and body parts) from the cells is still an open question. In addition, there still are open questions to healing and regeneration.

If a structure is found that is represented by what we now call the *phantom leaf*, it might, in part, be responsible for the direction of embryonic cells and/or regeneration.

Acupuncture

Thousands of years ago, the Chinese mapped several hundred points on the human body. These points identified paths in which a life force or vital energy flowed. Imbalances in the energy flow brought forth disease and sickness. *Acupuncture* is the name of this ancient method of Chinese medicine. It treats disease by sticking needles into various "acupoints" spread all over the body to correct energy imbalances and cure various diseases. Regardless of anyone's belief system, Acupuncture is commonly and successfully used in China as an anesthetic for minor (as well as for major) operations.

Many Kirlian researchers have claimed that Kirlian photographs of the human body show many of the acupuncture points. There does appear to be some scientific data that validates this proposal. Robert O. Becker, M.D., reported checking the electrical resistance of the human body and found a real electrical correlation at the acupoints on the human body. The electrical resistance, at approximately 50% of the

point locations on acupuncture charts, dropped significantly. Equally important is that these point locations exist at the same place on all test subjects.

Some doctors in China have incorporated modern technology into the ancient art of acupuncture. They target the acupoints and supply small currents of electricity through them pulsed at 2 Hz, instead of using needles.

Because this is so, it would appear reliable to assume that Kirlian photography would show these least-resistance points as small flares on the skin surface.

Psychic healing

A number of researchers, most notably Dr. Thelma Moss at UCLA and Douglas Dean have made Kirlian photographs of psychic healers. Psychic healing has a few synonyms such as *spiritual healing, laying on of hands,* and *magnetic passes.* It has been their hope to capture on film the healing energy or energy transfer.

From the numerous reports I have read on the topic, the results usually run like this. The healer's energy pattern (corona discharge) appears uniform and stable before attempting any healing. During the healing process, the discharge pattern increases significantly. After healing, the healer's discharge pattern shrinks smaller than their "before" healing base line.

The patient's energy pattern (corona discharge) typically increases after healing. It is sometimes believed that this type of healing accelerates the natural healing process.

Psychic healer on the TV show *Sightings*

In January 1993, I was contacted by Maggie Auth from Fox TV's show *Sightings.* She asked if I would be interested in shooting a few Kirlian photographs of a healer they were working with. The idea was to see if the Kirlian photographs could photographically capture any energy transfer or change in the healer or patient. I thought this to be an interesting experiment, so I agreed.

I scheduled the Kirlian shoot with Cynthia Crompton D.G.A. (the segment director) for Sunday January 17, 1993 at the Art Lab School at Snug Harbor on Staten Island. Working in one of the school's darkrooms, I shot six pieces of 4"-x-5" B/W sheet film, while demonstrating the procedure for the camera crew. The first three photographs were taken with the healer in a normal state to establish a base line. The following three photographs were taken with the healer in a healing state. During this time, the film crew shot the procedure we used under safelight illumination.

Following this, we used a night-vision lens to capture real-time Kirlian images using one of my transparent electrodes. We photographed coins, leaves, and (of course) the healer's fingertip corona.

After this, it was decided to shoot a few color sheets of film. To shoot color, it was necessary to turn off all lights, including the safelights so as to not fog the color film. The film crew for *Sightings* broke down and removed their equipment from the darkroom.

The healer and I followed the same procedure that was used when shooting the B/W film. In total, we shot 8 pieces of color transparency film. I used both daylight

and tungsten-balanced film to capture the most dramatic possible color fluctuations. The first four transparencies were shot to establish a base line. The four baseline shots consisted of using two sheets of daylight and two sheets of tungsten-balanced film. The next four pictures were taken with the healer in the healing state, again using 2 daylight sheets and two tungsten-balanced sheets.

When the color transparency film was developed, no corona images had been recorded on the film. The healer informed the film crew and myself that this had happened before. He claimed that his "power" was such that he turned off the electric equipment or counterbalanced it.

I told the healer that if this were the case, it only happened with the color film. The B/W film I recorded earlier had developed pictures perfectly. The healer became a little confused at this point, not realizing that I was really shooting B/W sheet film at the same time demonstrating the photographic procedure for the *Sightings*' camera crew. In addition, I explained that the real-time video that had been shot using the transparent electrode and night-vision lens didn't suffer any problems either. And finally, if his explanation was correct, then the first four color transparencies shot should have had an image on them because they were shot in his normative state, before he went into his healing mode.

This created a controversy as to what prevented the corona images from forming on the film. I explained to the *Sightings*' people that I didn't believe the laws of physics in the room changed once we turned out the lights to shoot the color film. I wanted to reshoot the healer to clear up this little controversy. Unfortunately, the film crew was on a tight schedule and could not stay another day in New York.

Had I been able to reshoot the healer, I would have taken precautions to prevent any intentional or unintentional procedural mistakes from corrupting or preventing the images. If you are called upon to use Kirlian photography to establish someone's psychic "power," take a lesson from my experience and be careful.

Pollution monitoring

Another viable area for Kirlian research is in monitoring pollution in various eco-systems. It might be possible to identify and classify Kirlian signatures to certain toxic compounds found in the environment. The most obvious use of this technology is detection of pollution. You might check a variety of eco-systems (such as soil, plant life, marine life, ocean water, and even municipal water supply systems). All these areas might prove to be valuable inroads into the usefulness of Kirlian photography.

Nondestructive testing in metallurgy

Kirlian photography has proven to be a method by which small fractures in materials can be detected without resorting to destructive testing. Although the methodology exists, I am not aware of any company testing materials in this manner.

The August 1966 issue of *Aerospace American* reported J.G. Michopoulos and G. C. Sih at Lehigh conducted feasibility tests of detecting metallurgy flaws using Kirlian photography.

The researchers used a small 20-watt generator and were able to detect flaws in materials to a shallow depth of 2 millimeters. The corrosion damage detected was hidden beneath the surface. In addition to detection, they were able to ascertain the severity of the damage. The researchers felt that with additional work, Kirlian photography could become an inexpensive method of nondestructive testing.

6

Second Kirlian device

This chapter features the construction of a second Kirlian device. This device has a little more sophisticated circuitry and a lot more versatility. Some additional features of this device are:

- Continuous operation
- Variable frequency control
- Safer discharge plate assembly
- Foot pedal operation
- Exposure timer control
- External connection wires

Circuit operation

Figure 6-1 is the circuit schematic. TR1 is a stepdown transformer that brings the standard line voltage of 120 Vac down to 25.2 Vac. The 25.2-V power output from the transformer is rectified by RECT and filtered by C1. Integrated circuit IC1 is a 7805 voltage regulator that provides the +5 V that is required of IC2, a 4049 hex inverter. Two gates of the IC2 hex inverter are configured as an adjustable oscillator using components C2, R1, and R2. The oscillator frequency is adjusted using potentiometer R2. The frequency range of the oscillator section is approximately 500 to 10,000 Hz. The output of the oscillator is fanned into three vacant gates on the same 4049 chip. The parallel output from these three gates provides sufficient current to trigger Q1, a TIP120 npn Darlington transistor. Transistor Q1, in turn, triggers Q2, a high-powered MOSFET. D1, a 200-V Zener diode, protects the MOSFET from reactive voltage surges by providing a clean path to ground. Resistor R4 provides current limiting through the MOSFET.

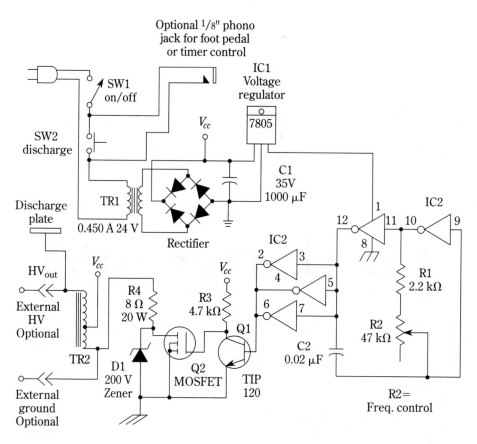

6-1 Schematic of the Kirlian device.

Circuit construction

The high-voltage transformer used in this circuit is the same transformer used in the first Kirlian circuit. This auto-transformer has three electrical leads. The two enamel wires located on the perimeter of the transformer are the power input wires. The green wire located at the center is the high-voltage output lead. Strip about 1½ inches of the green insulation from this wire to connect it to the exposure plate.

The housing for this device can be any nonmetallic case (made of plastic or wood) that is large enough to house the components. Use a panel-mounted "normally open" momentary contact switch to control exposure.

It's important to use a momentary-contact "normally open" switch. This switch requires you to keep constant pressure on the button to keep the discharge activated. Should any accident or mishap occur, your reflex reaction would probably be to remove your hand from the device, which would stop the discharge. If a standard switch was used, it would stay in the "on" position and require someone to physically turn the device off, during which time more damage or trouble could occur. The exposure plate and the controls are placed on top of the enclosure (see Fig. 6-2).

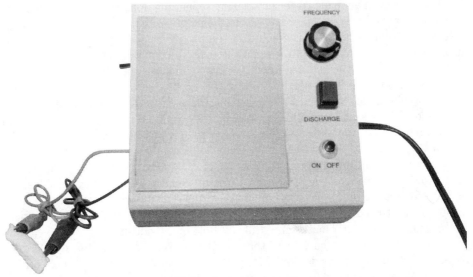

6-2 Photograph of the Kirlian device showing the top-mounted controls.

Exposure plate

The exposure plate is the next consideration. The plate is constructed from a 4"-x-6" single-sided copper-clad board. A ½"-to-¾" border around the edges of the board is stripped of copper (Fig. 6-3) using ferric chloride etchant, available from Radio Shack.

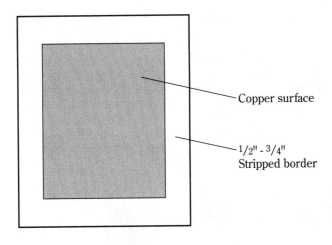

Copper surface

1/2" - 3/4"
Stripped border

Bottom side PC board
used for exposure plate

6-3 Copper-clad board with stripped border.

The board can be made larger or smaller, depending upon the overall size of the case used for the Kirlian device. The border helps prevent electrical arcing from the bottom side (copper side) of the board to the top when making photographs. This also makes it safer to photograph human subjects. You can purchase the plate with a stripped border (see the list of suppliers) or you can make the plate yourself.

Making the exposure plate Etching the exposure plate is easy. Fill a small plastic or rubber tray with ½" to ¾" of etchant. Place the copper plate in the tray on its side so that it stands vertically. Secure it in this position for 20 minutes. At the end of this time, remove the plate and rinse it in running water from the sink. You should have a ½" border that is clean of copper. If any copper remains in the border area, replace the board in the solution until it is completely clean. When the ½" border is completed on one side of the plate, repeat the process for the other three sides.

Mounting the plate Position the plate on the housing where you want it to be located. Mark the corners with a pencil and remove the plate. Find the approximate center of the four corner marks and drill a ¼" hole in the housing.

Reposition the plate back onto the top of the housing, using the four corner marks as a guide, copper side down. Mark the location of the drilled ¼" hole on the copper side, using a pencil from the other side of the housing.

Remove the plate and solder a wire in the center of your pencil mark on the copper side. The plate is then secured to the top of the housing permanently. Position the plate copper side down, with a wire going through the drilled hole in the housing. Glue or epoxy it into this position and let the glue cure. Figure 6-4 is a close-up photograph of the wire soldered to the plate through the plastic chassis. When the glue has cured completely, connect the end of the wire from the copper plate to the high-voltage wire on the transformer.

6-4 Close-up of the soldered wire to top-mounted copper-clad board.

Photographic exposures

Depending upon what you are photographing determines whether or not the object should be grounded. Although grounding an object intensifies the corona discharge, you should only ground inanimate objects.

Shooting models and live subjects

Figure 6-5 shows a typical set-up to shoot a fingertip corona. Notice the absence of a ground! The reason you don't need a ground is because the body's capacitance is sufficient to cause a discharge. Figure 6-6 is a black and white film exposure of two fingers.

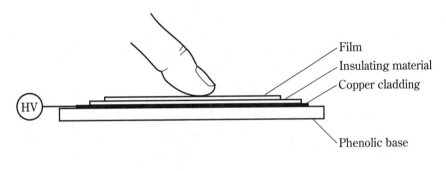

Film
Insulating material
Copper cladding
Phenolic base

Taking finger pad Kirlian photo

6-5 Schematic showing taking a Kirlian photograph of a fingertip.

6-6 B/W film negative of two fingers.

Safety first

When you are photographing a live subject (human or animal), under no circumstances should that subject be allowed to touch a ground while being photographed. Touching a ground while being photographed will result in a nasty electric shock for your subject. The three Kirlian devices outlined in this book generate inductive, high-voltage, low-current electric power. Under normal circumstances, the high-voltage, low-current electricity is not considered lethal to healthy individuals. However, this is no excuse to develop less-than-ideal safety conditions. In addition to never grounding a subject, never photograph anyone who has a heart problem or a pacemaker without their primary care physician's permission.

Grounding

Grounding the object, when appropriate, is a fundamental aspect of Kirlian photography and has been explained in chapter 3. When photographing an inanimate object (such as a leaf, coin, or keys), connect the object to a ground to get a better picture. A "ground" can be an electrical ground from the circuit or an earth ground from a cold water pipe. For more information on the circuit ground, see the section "external wire connections."

Exposures are usually made in complete darkness, unless you are using B/W ortho film or paper with a safelight, or specially packaged film from Images Company that can also be used under safelight illumination (see the index of suppliers). Even if you use standard color film, you may let a tiny amount of light in—just enough to see what you're doing. I have done so when I have shot a few Kirlian photos. However, I'm careful and only allow the light in intermittently, when I absolutely need it. So far, this light hasn't fogged my film.

When first making the room completely dark, allow a minute or two for your eyes to become accustomed to the darkness before proceeding. Place the film emulsion side up on the exposure plate. The film usually has a nick or mark in one of its corners. By placing the nick on your right-hand side, the emulsion side of the film will be facing you. Put the film on the discharge plate emulsion side up (with the nick on the top right hand side). Place the object you are photographing on top of the film. If the object is inanimate, connect the ground wire to it. Turn on the device and press the discharge button for 5 seconds to make the exposure.

Black and white doesn't have any nicks or marks to identify the emulsion side. It is assumed by the manufacturer that anyone using this film will also be using a safelight. Exposure time is determined by trial and error. Start with 5 to 10 seconds, and adjust it accordingly.

This device allows the frequency of the discharge to be varied. You can vary the frequency to obtain different effects. For instance, try sweeping through the entire frequency range for one effect. Or find the optimum frequency (resonant frequency) for the particular object that you're shooting. You accomplish this by sweeping through the entire frequency range to find the one frequency that provides the brightest discharge. Leave the frequency setting at this mark, set up and make an exposure at this frequency.

Figure 6-7 is a Susan B. Anthony coin shot with ½ second exposure. Figure 6-8 is a leaf at 3 seconds exposure. Figure 6-9 is a leaf using a diode ground (see chap-

ter 11 for more information). Figure 6-10 shows the same leaf—each exposed for 1 second. The top leaf, labeled 1 MΩ, had a 1-MΩ resistor connected between it and ground (see chapter 11 for more details). There are more photography ideas to try listed in chapter 11.

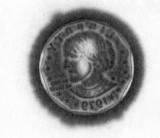

6-7 B/W paper negative of a Susan B. Anthony coin.

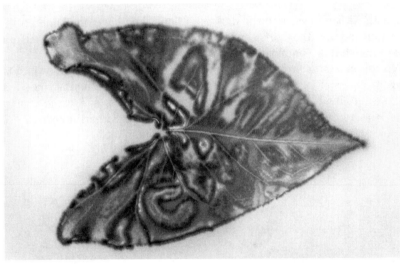

6-8 B/W paper negative of a leaf.

6-9 B/W paper negative of a leaf connected to the diode ground.

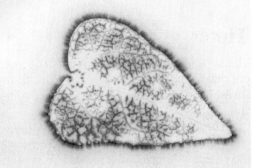

1 MΩ

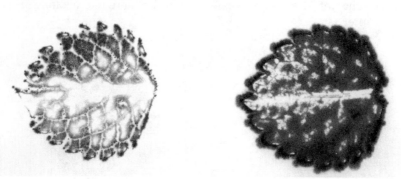

6-10 B/W paper of two leaves: one taken with a 1-MΩ ground.

Foot pedal switch

Working with Kirlian devices in the dark is difficult. You have one hand on the discharge switch and the other is free to hold and modify the setup. Having just one free hand isn't enough to accomplish much.

The solution to this problem is simple. Add an on/off foot pedal switch to free both of your hands (Fig. 6-11). The foot pedal switch is a momentary contact normally off switch. It's housed on top of any small enclosure. A 7' cable is an ample length of wire to connect the foot pedal switch to the Kirlian housing. The foot switch plugs into the side of the housing with ⅛" phono plug.

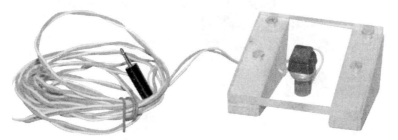

6-11 Photo of the foot pedal switch.

Timer

The same phono plug that is used for the foot pedal switch can also be used for a simple timer. The timer circuit can be set from 1 to 30 seconds to make timed exposures. The timer circuit provides an accurate measuring method to judge exposures and improve image-quality repeatability.

The timer circuit can also be incorporated into the foot pedal switch for added versatility. The timer circuit is built from a standard 555 timer chip (Fig. 6-12). Once the circuit is completed, it needs to be calibrated. Use a watch or a clock with a sec-

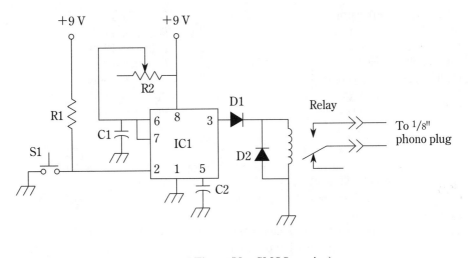

IC1 — 555 Timer (Not CMOS version)
R1 — 47 kΩ
R2 — 500k pot
C1 — 50 μf 15 V electrolytic cap
C2 — .1 μf cap
D1, D2 — IN4148 diode or similar

6-12 Schematic of the timer circuit.

ond hand to begin calibrating. Potentiometer R2 adjusts the time. Switch S1 is a normally open momentary-contact switch. Pressing S1 begins the timing cycle.

External connection wires

External connection wires from the high-voltage line and circuit ground allow different discharge plates and ground configurations to be connected to the basic Kirlian device. Most notable, are the transparent electrodes that allow you to use standard 35-mm and video cameras to photograph the Kirlian aura. In addition, you can use larger discharge plates to shoot larger 8"-×-10" sheet film or paper.

Use either heavy-duty or high-voltage wire. Solder an insulated alligator clip at its working end. Be careful with external wires; they carry the burden of additional shock hazards. Secure the ends of the external wires using the alligator clips, to a nonconductive piece of plastic when not in use.

Parts list for the second Kirlian device
Available from Radio Shack

TR1 120-Vac/25.2-Vac 450-mA transformer	PN# 273-1366
SW1 Momentary-contact normally open switch	PN# 275-1571
SW2 SPST 120-Vac switch	PN# 275-651
RECT 50-V 1-A rectifier	PN# 276-1185
C1 1000-μF 35-V capacitor	PN# 272-1032
C2 0.022-μF 50-V	PN# 272-1066

R1 2.2-kΩ ¼-W resistor PN# 271-1325
R2 50-kΩ potentiometer PN# 271-1716
R3 4.7-kΩ ¼-W resistor PN# 271-1330
R4 8-Ω 20-W resistor PN# 271-120
Q1 TIP 120 npn Darlington PN# 276-2068
IC1 7805 voltage regulator PN# 276-1770
IC2 4049 integrated circuit PN# 276-2449

From Images Co.

TR2	High-voltage transformer	$17.95
4"-x-5" Copper-clad board stripped with ⅜" border		$ 8.00
Q1	IRF830 MOSFET	$ 5.00
D1	1N5388 200-V Zener diode	$ 2.50
PC board		$12.00
4"×5"	Individually packaged color transparency film for daylight Kirlian photography	$ 4.00
Plastic instrument enclosure	6.25"×6"×3.25"	$20.00

Images Company
P.O. Box 140742
Staten Island, NY 10314
(718) 698-8305

7

Electrodynamics of life

Kirlian photography deals with high-voltage electrical fields. We can photograph the influence that objects and living specimens have on the discharge pattern in the field. Life on our planet has developed and is developing in electromagnetic fields. Most recently, we are living and developing in a very powerful artificially created electromagnetic field (60 Hz). The influence of electric fields and the parameters that control them have connections that can be visualized with Kirlian photography.

Origins of life

The origin of life begins at the creation of the universe. We don't need to go back quite that far. We can start at the formation of the earth, some 4.5 billion years ago, from a cloud of cosmic dust and gas. This dust and gas was leftover material from the formation of the sun. The material began to condense into a more compact mass that became the earth. As the earth condensed, a stratification of its components occurred. The heavier materials, such as iron and nickel, sunk to the core while the lighter materials became more concentrated near the surface.

Earth's present atmosphere is constructed of 78 percent nitrogen, 21 percent oxygen, 0.033 percent carbon dioxide, plus trace amounts of helium and neon. The primordial atmosphere of Earth was very different. It consisted of ammonia, water vapor, and carbon in the form of methane gas. It is believed that these types of atmospheres might exist on Jupiter and Saturn.

The primordial atmosphere was doused with energy in the form of heat, lightning, and UV light from the sun. An experiment carried out in 1953 by graduate student S. L. Miller, working under Harold C. Urey at the University of Chicago showed that when this primordial atmosphere is continuously passed through an electric discharge (spark), a large number or organic compounds are synthesized. In the years

that followed, many investigators have repeated this experiment and have synthesized a great variety of organic compounds.

Because of the lack of any free oxygen to "oxidize" the organic compounds on the primordial Earth, the organic compounds accumulated in the oceans for hundreds of millions of years, yielding a rich organic soup. Over the millions of years, it is guessed that the organic molecules began to self-organize and finally to self-replicate. The origin of life as we know it.

In 1974, F. E. Cole and E. R. Graf made a theoretical analysis of earth's Precambrian electromagnetic field. They theorized that the atmosphere was much larger and pushed the ionosphere further out into the Van Allen belts. An electromagnetic resonator was created out of the two concentric spheres; the upper atmosphere and the surface. Whereby as the earth's magnetic field combines with the solar wind, it induces large currents in the Van Allen belts. In the era Precambrian, these fluctuations in the Van Allen belt were in close contact with the expanded ionosphere. The ionosphere would have then coupled with the iron-nickel core of the earth and generated a constant electrical discharge through the atmosphere and into the earth. Calculating the distance around the core to be equal to 1 wavelength of electromagnetic energy at 10 Hz (18,000 miles), the discharge would have pulsed at 10 Hz throughout the resonant cavity.

If this is the case, it would be reasonable to assume that life created in this field and its descendants would resonate or be sensitive to a 10-Hz field. As it turns out a 10-Hz frequency is the primary EEG frequency in all animals.

As the 10-Hz discharge continued, the atmosphere slowly was reduced by the depletion of ammonia and methane into a soup of organic compounds. Eventually, the ionosphere shrunk to a point where it decoupled from the Van Allen belts. At this point, the currents would be too small to couple to the earth's core and the discharge would have shut off.

Today, there are still micropulsations in the earth's magnetic field from 0.1 to 25 Hz. Most of this energy is concentrated around 10 Hz.

Regeneration and electric fields

Regeneration was first studied in the 1700s by French scientist Reaumur. Working with lobsters, crayfish, and crabs, he proved that these animals did in fact possess the ability to regenerate lost limbs.

Around the same time, Abraham Trembley discovered the amazing powers of regeneration in certain small aquatic animals, what are now called *hydra*. Similar powers of regeneration were discovered in the starfish, sea anemones, and worms.

Lazzaro Spallanzani (Italian priest) added the next chapter in regeneration when he discovered the regeneration ability in salamanders. He studied regeneration and devised two basic rules of regeneration. Simple animals can regenerate more fully than complex animals. What we take this to mean in modern times is that the higher up on the evolutionary scale, the ability to regenerate declines (the salamander is the main exception to this rule). And if a species can regenerate, younger individuals do better at regeneration than older individuals.

Another piece of regeneration was added in the early 1900s: hydras were found to be electrically polarized, heads positive and tails negative. In the early 1920s, Elmer J. Lund found that the polarity of regeneration in a species closely related to the hydra could be controlled and reversed by a small external direct current passed through the animal's body. If the current was strong enough to override the creature's natural polarity, it would cause a head to regenerate where a tail should be and vice versa.

Electric fields of the human body

Harold Saxton Burr of Yale University read Lund's paper and began experimenting. Burr began by taking electrical measurements. He found electric fields around and measured electrical potentials on the surface of many organisms, such as salamanders, worms, and humans (and other mammals in general). He and his students measured the electrical changes and correlated them to growth, regeneration, tumor formation, drug effects, hypnosis, and sleep. Burr connected his sensitive voltmeters to implanted electrodes in trees. These tree measurements were made for years and they yield pretty interesting results. The tree's fields varied not only to the expected response to light and moisture, but also to storms, sunspots and the lunar phase of the moon.

The majority of Burr's work was conducted before World War II, so the instruments in use at that time were not as sensitive as today's. Burr was restricted to making what we'd consider rudimentary measurements of the gross electrical field. Subtle electropotential maps of the organism were not possible at this time. Despite this fact, Burr proposed an electrodynamic theory of life that stated that a *life field (L-Field)* is responsible and holds the shape of an organism. Whether you agree with Burr's hypothesis of an L-Field or not, much of Burr's work is quite interesting.

Harold Burr measured a large increase in electricity from women who were ovulating, as reported in the *American Journal of Obstetrics and Gynecology* 44:223, 1942. The report was titled "Electrometric Timing of Human Ovulation."

Building upon this success, Burr went to New York's Bellevue Hospital. Working with an obstetrician, they tested over a thousand women. In 102 cases, they found abnormal electrical potentials between the abdomen and cervix. In subsequent surgery for other complaints, 95 of these women had malignant cancers of either the cervix or the uterus. So, the electric field or resistance changed, becoming a diagnostic tool, before the disease manifested itself clinically. (H. S. Burr "Electromagnetic Studies in Women with Malignancy of Cervix Uteri," *Science* 105: 209 1947)

Burr continued to extrapolate from his research beyond what might be considered reasonable. He stated that he was able to determine a person's mental and physical health, evaluate job applicants, soldiers, mental patients, and suspected criminals.

The scientific community dismissed his work as ridiculous, but they did so without bothering to check his scientific data. Had they checked his data, they would have found the electrical fields Burr wrote about. They would have then had the opportunity if they didn't like Burr's electrodynamic theory to conjecture another the-

ory of their own to fit the experimental data. This did not happen and Burr was ridiculed.

Regeneration in mammals

Dr. Robert Becker investigated regeneration in many species up to and including man. In the beginning of his experimentation, he investigated the electrical polarity induced in the regenerating limbs of salamanders. First, measurements were taken at the sight of the injury before the injury was inflicted (Fig. 7-1). The uninjured extremity was slightly electronegative with reference to the torso area; this suggested a flow of electrons from the head and trunk of the salamander out into the limbs. Figure 7-1 shows the electrical potential at the injury sight before injury and as the salamander regenerated its right forelimb.

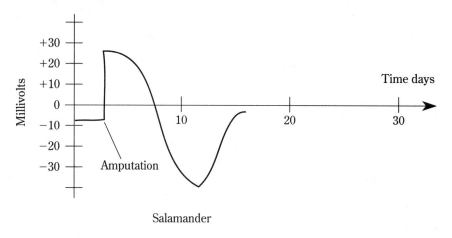

7-1 Graph showing the electrical potential of a salamander.

Continued experimentation with frogs and eventually humans proved that electronegative current could induce bone growth—even in stubborn fractures that (for the most part) refused to heal. In fact, bone knitting should be considered a minor form of regeneration.

Piezoelectric bones

Bones have been found to be piezoelectric. In 1954, Japanese orthopedist Iwao Yasuda first reported on this effect (Fig. 7-2). If the bone is stressed, an electric pulse is generated. In 1961, Robert Becker independently discovered the same effect. The compressed side of the bone became negative; the stretched side positive. The potentials reversed when the stress was released.

Because Dr. Becker already established that a negative potential induced bone growth, his next step was to see if there was a rectifier that would allow the negative potential from stressed bones to do work. The piezoelectric signal from the bone is *biphasic,* meaning it switches polarity with each stress and release. Without such a

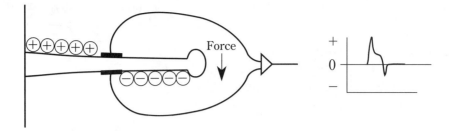

7-2 Illustration demonstrating the piezoelectric properties of a bone.

rectifier, the positive pulse from the bone would cancel the negative pulse. Through a series of experiments, they found a PN junction rectifier between two bone components *apatite* and *collagen,* that allowed the negative pulse to do work.

Dr. Becker went on to experiment with rats in 1971 and was able to induce regeneration in adult rats. Although the regenerated limbs were imperfect, this Dr. Becker feels has more to do with our crude rudimentary understanding of supplementing the regeneration process with tiny electric currents. The important thing to remember about this is that regeneration had been activated in an adult mammal, and although partial, it worked!

Brain waves

The fact that the brain generates electrical current was demonstrated in 1924 by Hans Berger. Berger measured the small electric field generated by the brain. He made the first *electroencephalogram (EEG) recording.* Today, brainwaves can be used to give a crude approximation of the state of consciousness.

Delta waves	0.5 to 3 Hz	deep sleep
Theta	4 to 8 Hz	trance, light sleep
Alpha	8 to 14 Hz	meditation, relaxed awareness
Beta	14 to 35 Hz	everyday consciousness

In 1939, W. E. Burge from the University of Illinois found a voltage potential between the head and other parts of the body, with the head appearing more positive. The potential of the extremities became more negative during physical activity, declined in sleep, and reversed polarity under general anesthesia.

Dr. Robert Becker measured the dc potential in the brain and found that the back to the front of the head varies with changes in consciousness (Fig. 7-3).

Electrosleep or *electronarcosis* is the induction of sleep by passing small currents through the head, temple to temple. The Russians have experimented widely in this area.

In 1986, *Discover Magazine* reported on Dr. Bjorn Nordenstrom from Sweden. He believes the mechanism of the body can be compared to a battery. Dr. Nordenstrom shrinks cancer tumors using electricity.

7-3 Graph showing electropotential that exists on the human head.

Smell

The olfactory glands send smell information to the brain as a 40-Hz FM signal.

Magnetic storms

Dr. Robert Becker's curiosity had been aroused from his electrical work with salamanders, bone healing, and acupuncture points. He wondered if the bio-magnetic fields of humans were influenced by external fields. In 1961, he had the opportunity to work with Dr. Howard Friedman, a VA hospitals chief of psychology. Dr. Becker explained his idea to see if there was any correlation between disturbances in the Earth's field caused by magnetic storms on the sun and the rate of psychiatric admission to the VA hospital where they were employed. With Friedman's influence, they analyzed the admission records from eight state psychiatric hospitals. In all, they analyzed over 28,000 patients over a 4-year period in which 67 magnetic storms occurred on the sun. They found a significant relationship. More patients signed in to psychiatric services just after a magnetic disturbance than when the field remained stable.

Magnetic fields, biocycles, and oysters

The influence of magnetic fields also affects other organisms. Frank Brown began his work with oysters in 1954. By this time, it had already been established that most organisms had a circadian cycle. It was assumed to be linked to the alternation of day and night. In the case of oysters, it was assumed linked to the tides. Oysters open their shells to feed when the tide comes in and covers them with water. This was a self-evident truth to any observer of shore life.

Brown noticed that oysters kept in an aquarium with constant light, temperature, and water level still opened and closed their shells in time with the tides. To study this phenomenon further, he decided to take specimens from Connecticut to his Illinois home in a lightproof box.

For two weeks after they had arrived in Evanston, Illinois, the oysters kept in tidal sync with their home in Long Island Sound, Connecticut. Then, there was a slippage in rhythm. All the oysters adjusted their tidal rhythm and began opening at a time the tide would have flooded Evanston if it was on the shore.

The oysters knew they had been moved 1000 miles westward and suffered jet lag to boot. The Earth's magnetic field changes slightly according to the positions of both the moon and sun.

J. D. Palmer, an associate of Frank Brown at Evanston experimented with Volvox aureus and magnetic fields. The experiment shown that the Volvox not only could detect a magnetic field, but were also aware of the direction of the lines of force.

F. Brown continued this experiment further using Nassarius obsoleta, a mud snail that lives in the intertidal zone. In his lab, he set up a coral for the snails. The coral had one exit facing magnetic south. In the morning, when the snails left the enclosure, they turned West. At noon, they turned East. At night, they turned West again.

Brown's data from this and other experiments showed that Nassarius had two biological clocks, one operating on solar time, the other one on lunar time. When Brown augmented the Earth's magnetic field with a 1.5-gauss magnet, the snails made sharper turns coming out of the enclosure, but their direction didn't change. Turning the magnet away from augmenting the Earth's magnetic field caused the snail's direction to change when leaving the enclosure. Brown's work was dismissed for many years by the scientific community.

Human compass

In 1975, Richard P. Blackmore astounded biologists around the world with the discovery of magnetotactic bacteria. These bacteria oriented themselves in a North-South direction on his microscope slides.

Electron micrographs of the bacteria revealed a chain of magnetite microcrystals orientated in a line within the cell. The crystals were surrounded by a thin cellular membrane. Research by other scientists revealed magnetic structures in bees and pigeons.

In 1984, zoologist Michael Walker found magnetite crystals in the sinus bone of yellow fin tuna and chinook salmon. The crystals were surrounded by an abundance of nerve endings. The crystals were organized similar to the chains found in the magnetotactic bacteria. Each magnetite crystal, although fixed in place, was able to rotate slightly in response to an external magnetic field.

Experiments in the late 1970s by R. Baker suggested that homo sapiens also have a magnetic sense of compass directions. In 1983, Baker discovered magnetic deposits close to the pineal and pituitary glands in the sinuses of the human ethmoid bone. This is the spongy bone in the center of the head behind the nose and between the eyes.

The location of the magnetic deposits to the pineal gland in homo-sapiens suggests the relationship to magnetic disturbances and the psychiatric admissions investigated and reported by R. Becker.

Negative ionization

Air is composed principally of nitrogen (78%) and oxygen (21%). In addition, air is typically full of positive and negative ions (app 5:4 ratio). When the balance of ions falls heavily into either region, the effects of the air ionization become apparent in biological systems.

This idea was popularized by Fred Soyka, who (in the 1970s) wrote a book titled "The Ion Effect." Mr. Soyka studied natural occurrences of negative and positive ionized air. His findings and inquiries demonstrated that negative ionization had substantial health benefits.

To summarize a few points in this book, negative ions help elevate mood, enhance physical performance and training, and sterilize harmful airborne bacteria. An abundance of positive ions on the other hand can be held responsible for a number of low-grade medical problems, such as fatigue, headaches, and anxiety.

Russian researchers working with Kirlian photography stated that the flares on the skin surface glow more brightly when the subject's lungs are filled with pure oxygen. The flares grow brighter still if the air is ionized. This may lead back to the yoga conception of breath as energy and air as prana.

60-Hz ELF

In the beginning of this chapter, it was stated that homo sapiens have developed in natural electromagnetic fields. More recently (in the last 100 years or so) the advent of electricity in our culture causes us to be surrounded with artificial electromagnetic fields that are more powerful than the natural fields. The impact these fields have on us biologically is just beginning to be studied.

There is a growing legitimate concern over the possible health hazards of low-frequency electromagnetic emissions. When the story first broke in this country, it concerned electromagnetic fields given off from overhead power-line transformers.

The reasoning that followed was that for most of us (unless we work in the electrical/electronic fields or live close to power lines), we could consider ourselves unaffected and relatively safe. But new evidence suggests that this really isn't the case. It appears that the ELF (extremely low-frequency magnetic) fields given off by many of our household appliances and computer monitors can be of sufficient strength to be considered potentially hazardous.

Although the mechanism by which ELF fields impact on biological tissue is not exactly known, it has been shown unequivocally that cellular tissue is affected. The best research to date shows the cell's membrane or receptor molecules in the membrane to be sensitive to extremely weak low-frequency magnetic fields.

Some of the effects reported so far include changes in the flow of ionic compounds through the cellular membranes, changes in DNA synthesis and RNA transcription and the response of cells to signalling molecules (such as hormones and

C-1 A bush exposure with device 1.

C-2 A leaf exposure with device 1.

C-3 A leaf exposure with device 3.

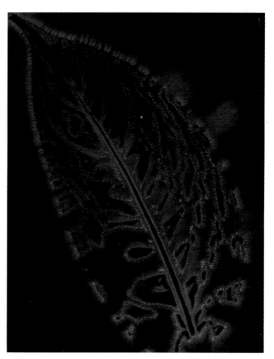

C-4 A leaf exposure with device 3.

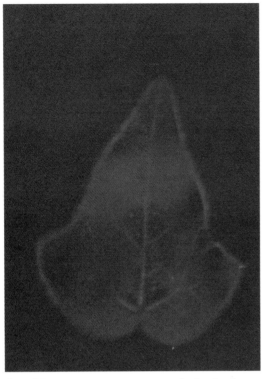

C-5 35-mm camera exposure of a leaf using a transparent electrode and a red filter.

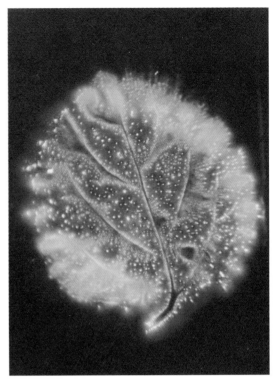

C-6 35-mm camera exposure of a leaf using a transparent electrode.

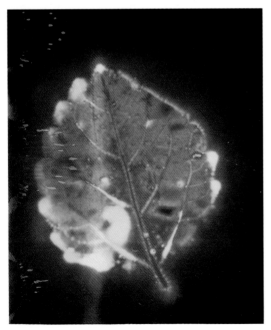

C-7 A phantom attempt.

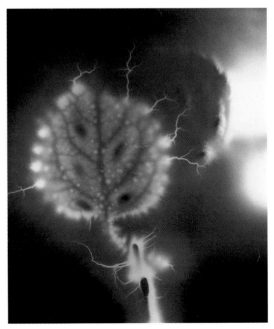

C-8 A phantom attempt.

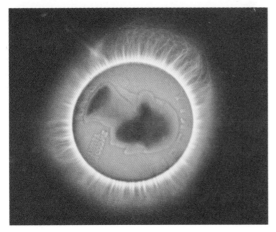

C-9 35-mm camera exposure of a coin using a transparent electrode.

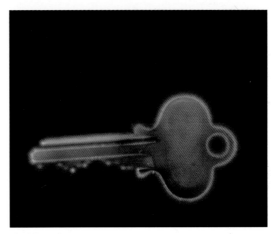

C-10 A key.

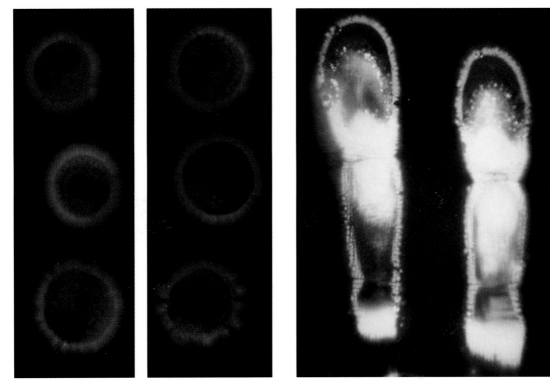

C-11 Six Roman coins, 2,000 years old.

C-12 Fingertip exposure.

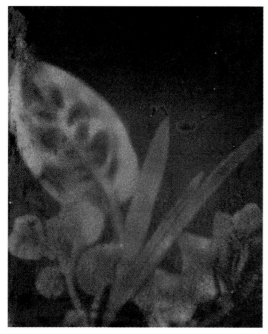

C-13 Dye transfer image on paper.

C-14 Polaroid print.

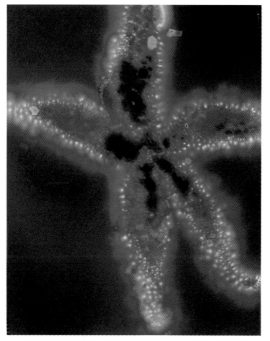

C-15 A starfish.

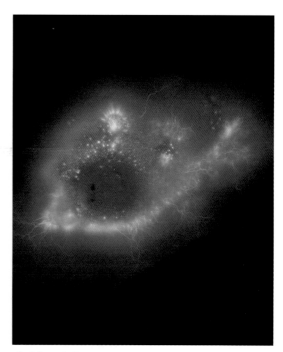

C-16 A fish.

neurotransmitter). In addition, changes have been noted in the kinetics of some cellular biochemical reactions.

The evidence against ELF

As studies progress, more information shall be forthcoming. Here is a short list of reported events that indicates the potential health hazards of ELF fields.

1972 USSR Soviet researchers link electromagnetic fields with low-grade health problems, such as fatigue and headaches.

1977 USA Robert Becker, physician, and biophysicist Andrew Marino testified before N.Y.S. Public Service Commission about the results of their experiments, which showed negative health effects as a result of exposure to ELF fields.

1979 USA Nancy Wertheimer, an epidemiologist, and physicist Ed Leeper publish a study which shows statistical link between childhood cancers and the proximity of certain types of high-current power lines to the home.

1982 USA A Washington State study examined the data for 438,000 deaths of workers in Washington State, occurring between 1950 and 1979. The results of the study found that leukemia deaths were elevated in 10 out of 11 occupations where the workers were exposed to ELF fields.

1986 Sweden Dr. Bernard Tribukait, a professor of radiobiology at the Karolinska Institute in Stockholm reported that the fetuses of mice exposed to sawtooth shaped electromagnetic pulsed fields had a greater incident of congenital malformation than unexposed mice. The sawtooth waveform is a typical waveform generated in CRT monitors.

1988 USA Maryland Department of Health and Hygiene found an unusually high rate of fatal brain cancer among men employed in electrical occupations.

1989 USA Johns Hopkins University found an elevated risk of all cancers among N.Y. Telephone Company cable splicers. An on-site reading of the ELF field showed exposure to 60 Hz ELF at approximately 4.3 milligauss.

1990 USA David Savitz, epidemiologist of the University of North Carolina has determined through a study that pregnant women who use an electric blanket have children with a 30% increased risk of cancer as compared to children whose mother didn't use an electric blanket.

Phantom limbs

Seventy percent of amputees experience pain or sensation in their amputated limb. This pain can be quite severe and doctors have been unable to formulate a definitive reason for these occurrences.

Some parapsychologists believe that the "phantom limb" is still attached to the body and causes the sensation. Scientists know that the brain creates our body sense. In the case of amputated limbs, they feel that the brain is creating the body sense of the lost limb.

Conclusion

This information hints that there is a lot more happening electrically inside our bodies than we know about. The impact that this information has on Kirlian photography is direct. The corona discharge from Kirlian photography can trace the electrical pathways in the body or under magnetic fields detail a subtle Hall effect. This chapter merely scratches the surface of what there is to investigate. The purpose is to open up and explore new avenues for research. This is a strong clue for the investigation of the phantom leaf experiment.

Many sensitives and psychics claim to see an aura around living organisms. This research doesn't preclude that their experience of an aura is imaginary or any less real. They might be reacting to or be sensitive to bio-magnetic fields or light of different frequency than what the average person can usually see. Historically, things that appear in folk lore often has some basis in fact.

8
Medical diagnostics

Since Kirlian photography was introduced into this country, it had been claimed that it could be used for medical diagnostics. In some cases, Kirlian photography would show an illness or disease present before any physical manifestations of the illness became apparent.

Psychology

In the October 26, 1973 issue of *Medical News,* two MDs (David Sheinkin and Michael B. Schachter), who were psychiatrists at the Rockland County Community Health Center in Pomona, New York, reported on their investigation of Kirlian photography's medical potential.

They were aware of the reports that the corona discharge pattern of a subject changed as a result of various illnesses. They attempted to make a controlled study to determine whether they would get the same kind of changes in the discharge pattern each time for a particular illness. Most of the patients that these doctors worked with had psychiatric problems, such as acute schizophrenic decompensation and alcohol psychoses.

With schizophrenia patients, they found a lack of clarity in the fingerpad corona. With one particular patient, the corona was almost nonexistent. Five days of treatment with medication brought the patient's schizophrenia under control, and subsequent photographs showed the finger pad corona was present with increased clarity.

The doctors also noticed corona changes in physical problems, such as pneumonia, gastroenteritis, and upper respiratory infection. The patterns they observed for GI disturbances were completely different from those associated with upper respiratory or psychiatric illnesses.

Professor of Psychology Bernard I. Murstein, Ph.D., and Serge E. Hadjoliam reported in the September 1975 issue of *Human Behavior* a positive correlation be-

tween aura size and attraction. If you are attracted to another person, this will show as an increase in the diameter of the corona discharge (aura). Dislike of a person or individual shows as a decrease in corona size.

In 1977, Lee R. Steiner, Psychology, Ph.D., authored a book entitled *Psychic Self Healing for Psychological Problems* that was published by Prentice-Hall. Ms. Steiner correlated evenness of fingertip corona discharges in Kirlian pictures to mental health. A bright, even corona discharge (aura) would be obtained from some-one who was mentally healthy. A broken pattern in the discharge showed a possible problem. An interesting thought that I had not read previously was her idea to pho-tograph both right and left index fingers and correlate them to right and left brain functions.

In 1982, at the International Congress of Medical Physics in Hamburg, Dr. Vitto-ria Marangoni presented results of her study using Kirlian photography. Dr. Marangoni and her colleagues examined several hundred psychiatry patients, most of whom were schizophrenics. They found that healthy people have a complete mostly blue corona discharge from their fingertips. In a schizophrenic, however, the corona is very patchy or is nonexistent. They also noticed a structureless red col-oration under the schizophrenics' fingertips.

Diagnostics

Although physiological and psychological differences in the human system have been shown with Kirlian photography, medical diagnostics had not been confirmed until the mid-1980s.

The difficulty in confirming the medical usefulness of Kirlian photography was that many doctors and scientists feared getting involved in Kirlian research. This fear was based on the publicity received by nonscience investigators who made sweeping and sometimes outrageous conclusions based on inadequate research.

The second major difficulty to overcome was the Kirlian photography equip-ment itself. Typically, the equipment does not control enough electrical parameters with sufficient precision to make the results repeatable. It took time, but eventually researchers slowly came back into the fray and overcame the difficulties in using Kir-lian photography for medical research.

Human skin

Figure 8-1 illustrates a cross section of human skin. Human skin is composed of two principal layers: the epidermis and the dermis. Aside from being the largest human organ, the skin is complex and is responsible for many functions.

As William Montagna of the University of Oregon had said: "skin is a remarkable organ—the largest and by far the most versatile of the body. It is an effective shield against many forms of physical and chemical attack. It holds in the body's fluids and maintains its integrity by keeping out foreign substances and microorganisms. It acts to ward off the harsh ultraviolet rays of the sun. It incorporates mechanisms that cool the body when it is warm and retard the loss of heat when it is cold. It plays a major role in regulating blood pressure and directing the flow of blood. It embodies the sense of touch. It is the principal organ of sexual attraction. It identifies each in-

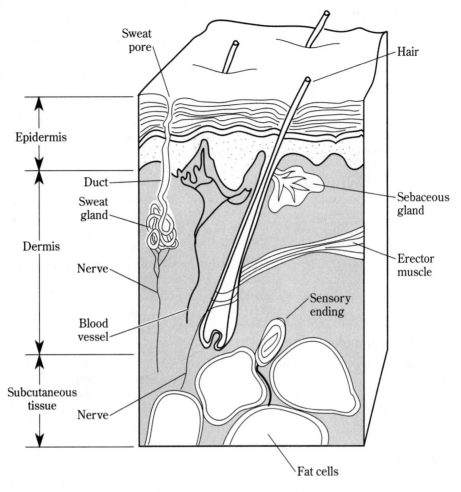

8-1 Cross section of human skin.

dividual by shaping the facial and bodily contours, as well as by distinctive markings, such as fingerprints."

Sweat glands

The skin on the palm of the hand has 370 sweat ducts per square centimeter (approximately 2500 per square inch). The sweat duct discharges the sweat electrolyte at an average rate of 6 to 7 pulses per minute.

Human sweat, unlike most other mammals, contains salt. The reason for salt excretion by the skin is not known. It had been suggested by pantologists that little crumbs of salt produced by the sweat glands of our primate ancestors clung to their fur and served as rewards for their companions who groomed them.

The sweat glands also excrete hormonal and waste products, such as urea nitrogen and lactic acids, which change the bio-chemistry of the skin surface. These changes can be recorded and used diagnostically with Kirlian photography.

Sweating can be caused by different physiological reactions.

1. *Thermal sweating* cools the body. Sweating occurs over the entire body surface.

2. *Emotional* or *mental sweating* occurs primarily on the palms of the hands and soles of the feet.

3. *Apocrine sweating* occurs primarily in the pubic region.

When in a relaxed state the sweat glands secrete only partially. As a result, the corona discharge is weak or partial. This matches with the *Galvanic Skin Resistance (GSR)* of human beings. The GSR of relaxed individuals increases.

Under emotional stress, the neural response is to shut down secretory activity. This prevents streamer formation in the resulting Kirlian photographs. However, under emotional stress, the GSR drops. So, although streamer formation from sweat glands might be curtailed, the overall corona discharge increases from a decrease in skin resistance.

Sexual stimulation increases *sudoriferous secretory activity* as well as the salt concentration in sweat. This increases the luminosity of the corona discharge. In general, ingestion of drugs that suppress the *Central Nervous System (CNS)*, suppresses sweating, which also decreases the corona discharge. Stimulants, smoking, and physical effort increase the corona discharge.

Electrolytes and electricity

No one doubts the complexity of the human body. The heart, powered by electrical impulses from the brain, pumps blood—an electrolyte solution—through the circulatory system. Changes in the body's electrolytes, pH of the skin, and sweat composition display differences in the Kirlian aura. Accurate interpretation of these factors is leading to the ability to use Kirlian photography for medical diagnostics.

Cystic fibrosis

Cystic fibrosis (Mucoviscidosis) is an interesting example of using Kirlian photography for detection. Why? Because cystic fibrosis is a genetic disease. Most people with CF have a single amino acid missing at location 508 in the CF gene product. This mutation is called *delta F508*.

Cystic fibrosis is a serious obstructive pulmonary disease that affects approximately 1 out 1500 children born in the United States. Other symptoms of the disease are a generalized dysfunction of the exocrine glands that may result in pancreatic insufficiency, elevated sweat electrolytes, hepatic cirrhosis, intestinal obstruction, and chronic pulmonary disease.

CF patients can be recognized by a characteristic x-ray and raised electrolytes in their sweat. It has been estimated that 5 percent of the overall population in the U.S. are carriers of the cystic fibrosis gene. The disease occurs when the defective gene is inherited from both its parents. People with one CF gene and one normal gene are carriers of the disease and do not show any of the disease symptoms.

Detection of CF using Kirlian photography The principal researcher L.W. Konikiewicz and Bejamin Shafiroff M.D. associate researcher at the N.Y. University Medical Center recorded biochemical changes on the skin of CF patients.

The concentration of electrolytes in CF patients' sweat is approximately 8 times greater than in a healthy individual. The electrolytes in the sweat are sodium (Na+) and chloride (Cl–).

The concentration of electrolytes causes a significant difference in the Kirlian photographs of healthy individuals and those with cystic fibrosis. In addition, carriers of the CF gene also show significant differences in their Kirlian photographs. Researchers standardized the procedure and photographed the thumb of individuals.

The main difference in the resulting photographs are that the CF patients have a characteristic pattern of uneven light emission around the finger. Carriers interestingly enough also show significant difference from the controls and their patterns overlap into the CF group.

Based on two blind studies, the Kirlian process was 88 percent accurate in determining CF homozygotes, 80 percent for CF hetrozygotes, and 62 percent for normals.

Usefulness as a CF detector Kirlian photography is not and might never be 100 percent accurate when testing for cystic fibrosis. The reason is that although the increased electrolytes in sweat are a strong indicator of CF, it cannot be used alone for CF diagnostics. High electrolytes in sweat can also be caused by adrenal insufficiency and a few other rare conditions. In addition, sweat salinity increases with age. So, where does that leave Kirlian photography in the diagnosis of CF? It might become useful as a preliminary test or quick screening, where a positive result will indicate another more intensive and expensive medical test.

Cystic fibrosis references Jones, J. E. and Konikiewicz, L. W.; "Detection of CF and CF carriers via electrography. Proceedings of the medical education day conference." 3-29-79. Polyclinic Medical Center, Harrisburg, PA.

Shwachman, H.; Mahmoodian, A; and Kopito, L; "A Standard procedure for measuring conductivity of sweat as a diagnostic test for cystic fibrosis." *J. Pediatr* :432-434. February 1965.

Monitoring menstrual cycles

The principal researcher L. W. Konikiewicz and Bejamin Shafiroff M.D. (associate researcher at the N.Y. University Medical Center) recorded biochemical changes on the skin of women that corresponded to their menstrual cycle. The data obtained showed a correlation between the corona discharge intensity and the blood levels of estrogen and progestogen.

One study contained eight young premenopausal women (group A). The study extended over a minimum of two menstrual cycles. Each day, the women had electrophotographs taken of their thumb pads. The images were analyzed for number of active sweat glands and intensity of photo-emission that corresponded to the activity of the sweat gland. Figure 8-2 charts the intensity of the corona discharge in relationship to the menstrual cycle phase.

The Kirlian photographs could show specific phases within the menstrual cycle: menses, follicular ovulatory, and lutein. Interestingly, women on contraceptive medication (Fig. 8-3), menopausal, and prepubertal did not show the regular modulation in their corona discharge.

This type of diagnostic tool is applicable in fertility and sterility cases.

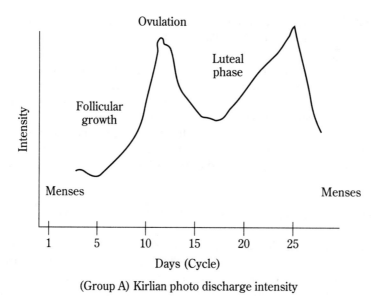

Ovulation

Luteal phase

Follicular growth

Menses Menses

Intensity

Days (Cycle)

(Group A) Kirlian photo discharge intensity

8-2 Chart showing corona discharge intensity in relationship to a woman's menstrual cycle.

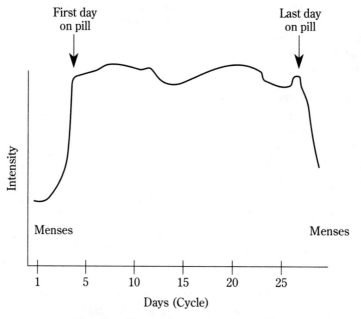

First day on pill

Last day on pill

Menses Menses

Intensity

Days (Cycle)

Female subject taking contraceptive pills

8-3 Comparative chart showing corona intensity for women taking oral contraceptive medication.

Menstrual cycle references Konikiewicz, L. W. and Shafiroff, B. J.; "Monitoring the menstrual cycle stages via electrography." *Osteopathic Physician*, May 1978. Lieberman, J.; "Cyclic fluctuation of sweat electrolytes in women." *JAMA*, Volume 195, Number 8, 1966.

Monitoring drug reactions

The body's response to many drugs can be monitored using Kirlian photography. Any compound that affects the *central nervous system (CNS)* or the electrolytes can be recorded. Preliminary studies show that not only the body's immediate response, but also the effectiveness of the given drug can be seen.

Figure 8-4 shows the body's response to valium. Although valium is classified as an anti-depressant, it is typically used as a relaxant. The body's immediate response is a sharp reduction in the intensity of the corona discharge. The intensity of the discharge gradually increases over a period of hours as the drug wears off. In contrast, Fig. 8-5 shows the body's response to the compound ritalin, a stimulant.

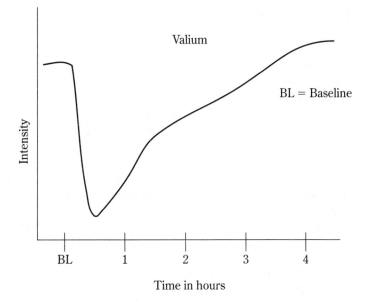

8-4 Chart showing corona discharge intensity in response to taking the drug Valium.

Detection of cancer

The sooner cancer is detected in an individual, the more effective the treatment and the greater the chances of a complete recovery. Present cancer detection methods include clinical evaluation, radiologic procedures, pap smears, mammography, barium enema, CAT scans, and ultrasound. In some cases, the detection process needs the malignancy to attain a certain size and state before it becomes detectable.

Many attempts have been made to find a biochemical marker that would identify when a cancer is present in a body. To date, no reliable agent has been found.

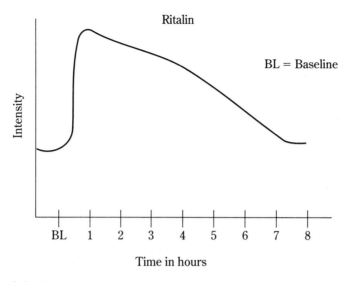

8-5 Chart showing corona discharge intensity in response to taking the drug Ritalin.

Researchers Leonard W. Konikiewicz and C. Griff used a Kirlian photography technique to detect cancer. Their reasoning was that the cancer causes metabolic changes on a systemic level that might be detectable. These two researchers had already demonstrated the effectiveness of using the technique by charting the hormonal changes of the female menstrual cycle and the specific patterns created by cystic fibrosis patients, as well as CF carriers.

Harold Burr in 1947 reported on his results of detecting cancer by measuring the electropotential. At New York's Bellevue Hospital, Burr (working with an obstetrician) tested over a thousand women. In 102 cases, they found abnormal electrical potentials between the abdomen and cervix. In subsequent surgery for other complaints, 95 of these women had malignant cancers of either the cervix or the uterus. So, the electric field or resistance changed, becoming a diagnostic tool, before the disease manifested itself clinically. (H. S. Burr "Electromagnetic Studies in Women with Malignancy of Cervix Uteri," *Science* 105: 209, 1947)

In the 1960s, Whitby found changes in the skin resistance of cancer patients. In 1962, C. Louis Kevron, a French scientist, found electrolyte imbalances. In leukemia, zinc levels are increased. In Hodgkin's disease, copper levels are altered. This helps explain the electrophysiological changes in cancer patients.

In the initial investigation, Konikiewicz and Griff examined 112 patients. The subjects were a mix of diagnosed cancer patients and normal people, who were used as controls. The researchers didn't know beforehand the patients' diagnosis or stage of disease.

It had been found that the hands of a healthy person over a period of time attracted less electrons (lower intensity corona discharge) than persons with cancer.

The methodology used consisted of taking 15 images at one minute intervals on x-ray film. The exposed film was developed, scanned, quantified, and charted. The

intensity of the corona discharge was scaled from 0 to 10. A mean intensity value of 0 to 5.5 was considered normal; 5.51 to 6.5 was judged to be borderline; 6.51 to 8 was positive; and 8.01 to 10 was highly positive.

Each subject washed their hands with surgical detergent just before photographing. In healthy subjects, sterilization of the hands lowers the skin's ability to attract electrons, resulting in a low-intensity discharge. The recovery time for this test is slow: approximately 10 to 30 minutes, depending on the individual (Fig. 8-6).

8-6 Chart showing relative intensity of 15 Kirlian photographs of a subject with no malignant disease.

With cancer patients, the results are quite different (Fig. 8-7). The recovery time is quite short—approximately 1 to 3 minutes.

Of the 112 patients used in the study, 24 patients were diagnosed as normal (no malignant disease), 87 subjects were diagnosed to have a malignant disease and one subject was diagnosed as a possible malignancy.

The Kirlian process correctly identified 98 patients (87.5% correct). Seven of the 14 mismatches were found to be as a result of the effects of medication at the time of diagnosis. If you exclude the seven patients under medication, which was found to affect the results, the Kirlian process becomes 93.8% effective.

No medical tests are 100% and the Kirlian process is no exception. The data clearly indicates the effectiveness of using this procedure. What is hoped for is research in testing the process for the early detection of cancer.

Cancer references Griff, L. C., Konikiewicz, L. W., and Moyer, K.; "Bioelectrography in cancer detection." *Pennsylvania Medicine*, October 1983.

Konikiewicz, L. W. and Griff, L. C.; *Bioelectrography—A new method for detecting cancer and body physiology*. Harrisburg: Leonard Associates Press, 1982.

Whitby, H. A.; *Bioelectronic detection of cancer and other diseases. Methods of diagnosing symptomless disease*. Spring field: Charles C. Thomas, 1967.

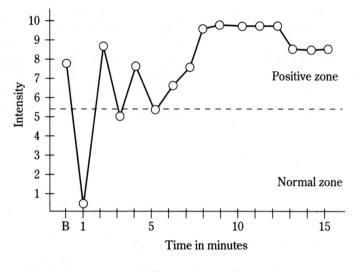

Malignant disease detected

8-7 Chart showing relative intensity of 15 Kirlian photographs of a subject with a malignant disease detected.

9
Transparent electrodes

Transparent electrodes allow you to use standard film cameras or video cameras to photograph the corona discharge. Because there is no direct contact between the film and the object creating the corona discharge, there are no color artifacts introduced by either direct contact or film buckling. Most Kirlian photographs taken with a transparent electrode show the accurate blue-ultraviolet color of the discharge.

The color of the discharge can be analyzed by spectrographic analysis or simple bandpass filters. The color of the discharge can be changed artificially for special effects by using colored filters in front of the camera.

Tin-oxide plastic

The heart of the electrode is a clear sheet of plastic that has a tin-oxide coating on one side. The conductivity of the tin-oxide coating is about 100 ohms per square inch. At this conductivity level, the tin-oxide coating on the plastic still transmits 90 percent of the incident light.

When you receive the plastic sheet, it will be difficult to tell visually which side of the plastic has the conductive tin-oxide coating. To determine the coating side, you need an ohmmeter. Inexpensive VOMs (volt-ohm meters) are available from Radio Shack for about $12.00. Set the VOM to OHMs on maximum resistance and touch one side of the plastic sheet with the two probes. The side with the conductive coating will deflect the meter (Fig. 9-1).

Construction

The biggest problem to overcome when making a transparent electrode for Kirlian photography is making a good electrical connection to the tin-oxide side of the electrode. Without a good electrical connection, the HV source would quickly vaporize the

Ohmmeter

9-1 Detecting the conductive
side of a transparent
electrode with a VOM meter.

Testing for tin oxide coating
on transparent plastic

conductive coating and render the electrode useless. Soldering a wire is out of the
question because the heat would melt the plastic and vaporize the delicate coating.

The answer I've come up with is to use electrically conductive silver epoxy. To
alleviate any vaporizing of the conductive coating from a single-point connection, I
used a ring electrode that makes contact with the tin oxide on all its edges (Fig.
9-2). The edge electrode can be made from single side copper-clad board. The cop-
per-clad board I used was only 0.031" thick. Because of its extreme thinness, I was
able to cut the copper-clad board with a pair of scissors. This made it easy to manu-
facture the electrode. You can use a standard-thickness copper-clad board.

The copper-clad board is cut to the same size as the transparent electrode with
a tab running off one corner for the electrical connection. The tab should extend
about 2" away from the edge of the board. Next, cut away the inside of the board and
leave a ½" to ¾" border, which makes a rectangular ring electrode (Fig. 9-2).

9-2 Ring electrode fabricated
from a piece of thin 0.032"
copper-clad board.

Rectangular ring electrode

When the copper-clad board has been fashioned into the electrode, take some steel wool and clean the copper side of the board until the copper is a hot pink color. Rinse the board with plenty of water to remove any trace of soap that may have been left by the steel wool pad.

Mix the epoxy, according to directions, and apply it completely around the copper side of the board. Then, place the transparent electrode conductive side facing the copper side on top of the ring electrode. On to this, place a sheet of glass or plastic to hold the entire transparent electrode assembly flat while the epoxy cures.

One peculiarity of the silver epoxy is that it needs a gentle heat treating to become conductive and to form a good bond. To do this, use an incandescent table lamp. Keep the lamp approximately 6" to 9" away from the assembly for about an hour.

Test the assembly with an ohmmeter before proceeding. Touch one probe to the copper tab and touch the other to the tin-oxide coating. The conductive side of the transparent electrode is delicate; you need to protect it from damage as much as possible.

Purchase a sheet of ⅛"-thick transparent plastic. You will find this material at any well-stocked hardware store. Thickness isn't critical; ¹⁄₁₆" or ³⁄₁₆" thick will work as well. Cut a piece of plastic from the sheet that is 2" larger in both width and height than the transparent electrode.

While you're in that well-stocked hardware store, purchase a dozen plastic or nylon machine screws (½" to ¾" long) with 2 matching nuts for each screw. It's important for the screws and nuts to be made from a nonconductive material, such as plastic or nylon. This will eliminate a shock hazard. Thread size isn't important—anything around 8-32 will work fine.

Drill 8 small holes that are large enough to fit the machine screws (Fig. 9-3). The holes should be located on the border of the sheet so that the tin-oxide electrode can be placed in the center without getting in the way of any holes.

Acquire another piece of transparent plastic; this piece should be pretty thin, about 0.005" to 0.010" thick. Plastic this thin is usually flexible, which is alright. This plastic can be found in office supply, drafting, or craft stores. Cut a piece the same size as the ⅛" thick plastic. Lay the plastic on top of the ⅛" plastic and punch a hole in it at the same location as the holes on the ⅛" thick plastic.

9-3 Plastic sheet (⅛" thick) for the transparent electrode.

You now have all of the components to assemble the electrode (Fig. 9-4). First, get the tin-oxide electrode, place small amounts of glue along the border on the copper side. Don't use so much glue that it will get pushed beyond the border area in front and on top of the tin-oxide coating when placing it down. Place the electrode down on the ⅛" plastic copper side that is facing the plastic. Make sure that it's centered and out of the way of the holes. Place a book or flat object on the electrode to hold it flat while the glue dries. After the glue has dried, place the thin piece of plastic on and secure it with the machine screws and nuts.

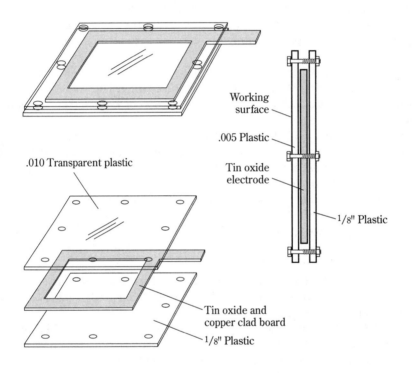

Working surface

.005 Plastic

.010 Transparent plastic

Tin oxide electrode

1/8" Plastic

Tin oxide and copper clad board

1/8" Plastic

Assembly

9-4 Assembly of a transparent electrode.

The reason that the thin sheet of plastic is held by the machine screws is to make it replaceable. This is the working surface of the electrode. In other words, this is the side that will face and touch the object that you are photographing. If and when it becomes scratched, marred, or cloudy with use, it can easily be replaced.

Simpler alternate method

The original transparent electrode used 2 pieces of ⅟₁₆" thick plastic on each side of the conductive electrode. I found that it required too much power to get a visual image through the ⅟₁₆" thick plastic. Therefore, I changed one of the ⅟₁₆" plastic sides for much thinner 0.005" to 0.010" thick plastic. This worked much better with all the Kirlian de-

vices. Because you are not using a thick piece of plastic on the front of the conductive electrode, there is a much easier method of fabricating the transparent electrode.

First, you can eliminate drilling the holes in the ¹⁄₁₆" plastic and eliminate the nylon screws and nuts. Glue the conductive electrode to the ¹⁄₁₆" transparent plastic as before. When the glue cures, tape the 0.005" to 0.010" plastic to the front of the electrode. When the 0.005" plastic wears out, remove the tape and replace the plastic.

Use

The transparent electrode can be used with any of the Kirlian devices, provided they have external wires for connecting the HV to the transparent electrode and ground wire to the object when appropriate.

Typically, the camera is located on the opposite side of the working surface. Because the electrode is transparent, you can shoot through the electrode as if it were a pane of glass. As an example, here is the procedure to shoot a leaf. In this example, the leaf is at ground potential and the transparent electrode at the high-voltage potential. The polarities of the object and electrode are not important for this example and can be reversed for different effects, if you wish.

Examine Fig. 9-5. This details one simple arrangement. You should make this set-up in a room that can be made relatively light tight. The leaf is placed on a black nonreflecting, nonconductive surface. This improves the background contrast in the picture. The transparent electrode is placed over the leaf. The leaf is connected to ground by an alligator clip wire (type 1 grounding). The transparent electrode is connected to the HV supply with another alligator clip wire.

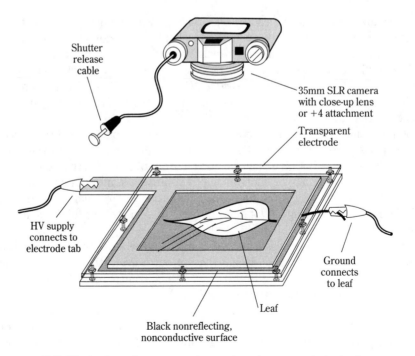

9-5 Illustration of a camera set-up using a transparent electrode.

The camera is positioned over the assembly. The lens on the camera should only show the area under the transparent electrode. This is accomplished with either close-up lens (macro), a +4 adaptor, or a reversing ring. The camera should be manually focused onto the object. If an auto-focus camera is being used, set the focus to manual operation. Open the aperture (F-stop) of the camera as far as possible: F-stop 2.0 or 2.4. Set the shutter to B (bulb) to make long timed exposures. With the shutter set to B, the shutter remains open as long as pressure is kept on the shutter. Using a shutter-release cable attached to the camera will make taking the pictures much easier. You can use any type of color film in the camera, I advise using the fastest film available, either ISO 1000 or ISO 1600.

Focus on the object with the lights in the room on. After the camera is focused on the object, all the lights in the room are shut off. Use a flashlight with a deep red filter to navigate around the room. Turn off the flashlight if it's on and open the shutter of the camera using the cable release. Now, activate the Kirlian device for a few seconds to make the exposure. Turn off the device and close the shutter of the camera.

It's difficult to give an exact exposure time; you will have to determine that through trial and error. If you are using 1600 film, I would try 5- to 10-second exposures. One hint you might like to follow is to start each roll of film with a few conventional pictures. This allows the photo-developing store to align the film frames properly in the machine. Tell the photo store to print all frames; they might take the glowing outlines and auras as picture errors and not print them.

View box

A simple viewing box makes it easier to photograph Kirlian images with the transparent electrode. The box allows the camera to be held in a horizontal position. This is almost essential when you want to shoot real-time Kirlian images using a video camera.

The box is illustrated in Fig. 9-6. The box is made from ¾" thick board. The mirror required for the box is a *front-surface (FS) mirror.* For those of you not familiar with optical mirrors, a front-surface mirror has its reflective coating on its front surface (as the name implies).

Standard mirrors have their reflective coating on the backside of the glass. This way, the glass protects the reflective coating. The disadvantage with the standard mirror in an optical situation is that the glass in front of the reflective coating also reflects a faint double image or ghost image. If you use a standard mirror in the box, you will photograph that faint double image with the primary image. The double image is distracting, annoying, and it degrades the final image. For this reason, a front-surface mirror is highly recommended.

The front-surface mirror is mounted at a 45-degree angle using a wood bracket on each side (Fig. 9-6). Two screws at the bottom prevent the mirror from sliding out. The top of the box is made from ¹⁄₁₆" to ⅛" thick transparent plastic. The plastic is secured in place using four wood screws.

To use the box, place the transparent electrode on top of the box. Connect the high-voltage source to the electrode. Place the object you are photographing on top of the transparent electrode. Connect a ground wire, if appropriate, to the object.

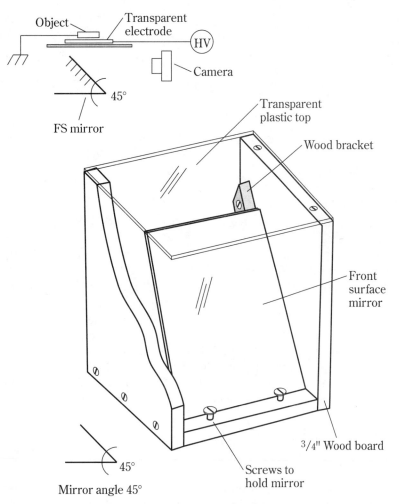

9-6 View box for shooting Kirlian photographs with a transparent electrode.

Set the camera to look straight into the FS mirror. You should be able to see the reflection of the object you are photographing in the mirror. The camera should be manually focused onto the object. If an auto-focus camera is being used, set the focus to manual operation. Open the aperture (F-stop) of the camera as far as possible; F-stop 2.0 or 2.4. Set the shutter to B (bulb) to make long timed exposures. With the shutter set to B, the shutter remains open as long as pressure is kept on the shutter. Using a shutter-release cable attached to the camera will make taking the pictures much easier. Turn off all lights in the room. Activate the Kirlian device and open the shutter on the camera. If you are using ISO 1600 film, try 5- and 10-second exposures. C-5, C-6, and C-10 show 35-mm images shot using a transparent electrode.

Daylight use

It is easy to modify the view box so that it can be used in a well-lit room. After the object and camera have been properly set up, cover the entire set-up with a black cloth and shoot the pictures.

Video cameras

A video camera can be substituted for the 35-mm camera to make real-time video images of the Kirlian aura. Close-up lenses are still needed for video cameras to achieve good-quality pictures.

Light intensifiers

Using a transparent electrode allows you the exciting option of using *light intensifiers*. Light intensifiers can magnify light 5000X to 70,000X. They are used mainly in astronomy, military operations, and surveillance. The first generation of light intensifiers (IR) usually magnified light mostly in the infrared (600-1000 nm) portion of the spectrum. This is not where the Kirlian corona discharge radiates most of its energy. Do not use a first-generation IR type of image intensifier. The newer second-generation (light amplifiers) light intensifiers magnify visible light down to the infrared portion. The second-generation tubes are more suitable for Kirlian research.

Light intensifiers would make the Kirlian aura quite visible. It would also assist in looking for and possibly confirming the phantom leaf phenomenon. Light intensifiers can be used in a handhold mode; hold it in your hand to view using your eye, or adapters can be mounted onto a standard 35-mm camera or video cameras.

Inexpensive low-resolution transparent electrode

The plastic with the conductive tin-oxide coating is fairly expensive. One inexpensive alternative is to build a low-resolution transparent electrode. The heart of the electrode is a metal screen. You can use the type of metal screen used in storm doors because it is readily available in hardware stores. If you decide to purchase a screen just for the purpose of building a transparent electrode, keep this in mind. Purchase a screen made from the smallest diameter wire available. You can vary the mesh spacing, anything around ¹⁄₁₆" will work. The diameter of the wire and the mesh spacing determines the transparency of the electrode.

Cut a small rectangle of screen, approximately 2"×3". Strip ½" of insulation off a 14" wire. Solder it to one corner of the screen. Cut two pieces of transparent plastic that are 4" ×5". Center the screen on one piece of plastic. Secure it with tape or glue. Place a second piece of plastic on top. Secure both pieces of plastic by taping the edges together (Fig. 9-7).

To use this system, simply place the electrode on top of the object you want to photograph. Connect the electrode wire to the high-voltage source and the object to the ground (only if it's appropriate). Set up the camera and you're ready to shoot.

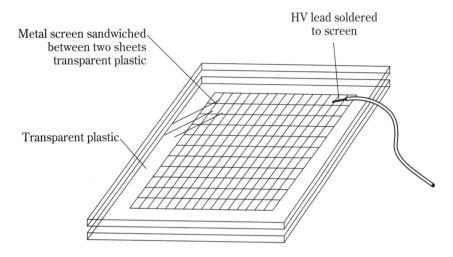

Metal screen sandwiched between two sheets transparent plastic

HV lead soldered to screen

Transparent plastic

9-7 Illustration of a low-resolution transparent electrode.

Inexpensive liquid transparent electrode

Another way to make a transparent electrode is to use a conductive liquid. The conductive liquid produces a high-resolution electrode. However, the conductive liquid can be a dangerous shock hazard. *Do not attempt this project unless you are experienced and comfortable working around high-voltage supplies.*

The electrode itself is quite simple. A small plastic or glass dish is filled with ⅛" to ¼" of a conductive fluid. For my dish, I used a small 4"×5" rectangular plastic frame for pictures. These inexpensive frames cost about $2.00 and can be purchased at most inexpensive department stores. The sides of the frames are over 1" high.

The conductive fluid is made by mixing a small amount of common table salt in water. An HV lead wire is stripped and dipped into the water (Fig. 9-8).

The object to be photographed is placed underneath the dish. You might need spacers on each side of the tray to prevent the dish from crushing the object. Grounding the object is usually best accomplished by using the type-2 ground configuration.

Closed liquid electrode

By using the same principle as the open liquid electrode, you can make a closed electrode for photographing larger objects. Find a plastic jar with a tight-fitting plastic cap. Keep the diameter of the jar as small as possible. Drill a small hole in the cap for the HV lead wire. Strip 3" of insulation off a 48" wire. Thread the wire approximately 4" to 6" through the cap. Epoxy the wire in the hole so that the epoxy also forms a waterproof seal. Fill the bottle with a salt solution. Put epoxy on the threads in the cap and on the plastic jar, then tighten cap onto jar and let it cure (Fig. 9-9).

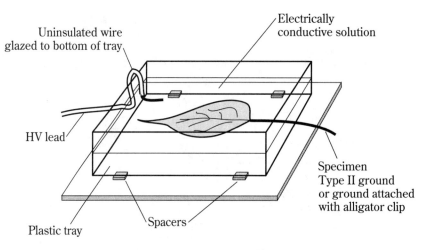

Uninsulated wire
glazed to bottom of tray

Electrically
conductive solution

HV lead

Specimen
Type II ground
or ground attached
with alligator clip

Plastic tray

Spacers

9-8 Illustration of a liquid transparent electrode.

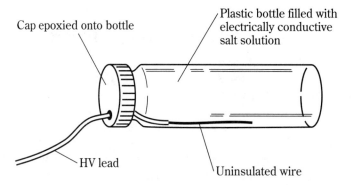

Cap epoxied onto bottle

Plastic bottle filled with
electrically conductive
salt solution

HV lead

Uninsulated wire

9-9 Illustration of a closed liquid electrode.

After the epoxy cures, connect the HV source to the lead. In a darkened room, you can trace the bottle over large objects and you will obtain a glowing discharge. Using a camera in the B setting, you can trace over large objects in the dark and make Kirlian prints.

Close-up photography

A transparent electrode works great. However, without the proper lens, your photographic results will not be very impressive. In this section, it is assumed that you will be working with a 35-mm single-lens reflex (SLR) camera.

Because you are usually photographing a small 4"-×-5" area, it is to your advantage to use a close-up lens. The close-up lens will expand the 4"-×-5" area (or a portion of it) to fill the entire field of view of the camera. Without these lenses, the Kirlian window would be too small to show much detail.

Some possible pieces of equipment include: extension tubes, a bellows attachment, macro lenses, or a lens-reversing ring. Close-up lenses screw onto the front of your camera lens like filters.

Extension tubes attach between the camera body and lens, increasing the distance between the film plane and the lens, and thereby increasing magnification. Bellows units are really an adjustable extension tube; magnification up to 20X is possible with the correct lens attachment.

Close-up lens

The simplest and least expensive way to get your lens to focus closer up is by using a close-up lens. These lenses screw on to your standard lens, just like a filter. Close-up lenses are rated in *plus diopters.* The number of the diopter is relative to its strength. A +1 diopter will let you focus on an object 1 meter away. A +2 diopter will let you focus ½ a meter away. A +3 diopter ⅓ a meter away, +4 diopter ¼ meter away, and so on.

When purchasing a close-up lens, find out your lens size before you go to the camera store. This tells you the thread size that you need, such as 49 mm, 52 mm, etc. You can purchase close-up lenses individually or in a set, which usually contains three lenses: +1, +2, and +3. If you purchase a single close-up, I advise getting a +3 or + 4 diopter.

Close-up lenses don't take you much closer than life size, 1:1, which for all purposes is fine for this work. The other gotcha is some loss of image sharpness—especially around the edges. The loss of sharpness becomes greater as the diopter strength increases.

Lens-reversing ring

The *lens-reversing ring* is another inexpensive close-up photography technique. The lens-reversing ring has a camera body mounted on one side and a threaded ring on the other. The ring is screwed onto the lens. The lens is then removed from the camera body, turned around and reattached using the other side of the reversing ring. Your lens will now focus very close to the object and simulate a simple macro lens.

Extension tubes and bellows

If you get into more serious close-up work, you will want to work with extension tubes or a bellows attachment. These devices provide crisp sharpness. These attachments also provide larger-than-life magnification.

Special effects

Because Kirlian photography can be used as a special effects technique, you might sometimes forget that you can combine this technique with other techniques. A few ideas you might want to consider are colored filters, focus effects, zoom lenses, and multiple exposures.

Parts list for chapter 9
Tin oxide
Plastic sheets
Metal screens
Transparent plastic sheets
Rectangular transparent plastic trays
HV wire
Front-surface mirrors

Available from:

Images Company
P.O. Box 140742
Staten Island, NY 10314
(718) 698-8305

10
Phantom leaf experiment

The phantom leaf experiment is the most interesting reported phenomenon in Kirlian photography. If this phenomenon is verified, it will prove the existence of the bioplasma that is so often quoted from Russian literature. To observe the phenomenon, a small portion of a leaf is cut away before photographing. Sometimes, very rarely, the missing portion of the leaf shows up in the Kirlian photograph as a faded apparition.

History

Russian researcher Adamenko, as well as other Russian researchers, claim to have photographed a phantom leaf on more than one occasion. One theory held by this Russian scientist is that the greater part of the leaf is forming a holographic pattern of the missing section. He goes on further to say that this coherent energy pattern might help to organize and build matter. A type of morphogenetic field is described in chapter 5.

In Brazil, H. G. Andrade claims to have recorded a phantom leaf (H. G. Andrade, "O Efeito Kirlian," *Instituto Brasilerio de perquisas psicobiofisicas*, San Paulo, Brazil, 1972). One of his phantom leaf photographs was used as the cover for the book *The Kirlian Aura* edited by Stanley Krippner and Daniel Rubin.

American researchers Thelma Moss, Ph.D., and Kendall Johnson working at UCLA in California claimed to have obtained a number of phantom leaf photographs. Moss, T., *The Probability of the Impossible*, J. P. Tarcher Inc., Los Angeles, 1974, and Johnson, K., *Photographing the Non-Material World*, Hawthorn Books, NY, 1975.

In 1979, three researchers, Prof. J. K. Choudhury, Dr. P. C. Kejariwal, and A. Chattopadhyay, working under a grant from the Department of Science and Technology Ministry of Education, Government of India, published papers in which they described the necessary parameters by which they observed the phantom leaf phenomenon. They claim their repeatability rate approaches 50%. The critical frequency according

to the researchers lies between 20 to 35 Hz with a polarized voltage of approximately 20 kV. This paper is an exception to the usual phantom leaf reports because it gives the parameters upon which the phantom leaf was obtained.

Dr. Thelma Moss, Ph.D., stated in a 1981 lecture at an international healing symposium in Washington, D.C. that by using chloroform, a phantom leaf could be obtained close to 50% of the time.

Proponents

The proponents of the phantom leaf say that it is clear proof of a bio-plasma energy field that encompasses and surrounds all living things. According to S.D. Kirlian and his wife Valentina, the principle behind Kirlian photography is the transformation of nonelectric properties of the photographed subjects into electrical ones caused by the high-voltage potential.

Opponents

The opponents of the phantom leaf state that the phantom leaf is an artifact, created by those that are either deluding themselves or are intentionally perpetrating a fraud. Why is the scientific community being so hard on these researchers? Simply, the Kirlian researchers don't know or haven't published the exact conditions under which the phantom leaf was obtained. So the scientific community cannot replicate the phantom leaf results that they claim to have obtained. Scientists, in general, feel the aura created by Kirlian photography can be explained by the known physical laws of the corona discharge. Proof of this is that any conductive nonliving object can also produce an aura.

Fake phantom leaves

Photographic evidence of the phantom leaf phenomenon is unreliable. The simple truth of the matter is that they are far too easy to fake. Even legitimate researchers can mistakenly create a pseudo phantom leaf by accident.

One way that a fake phantom can appear is when the full leaf is first photographed. The film is replaced with a fresh sheet, a small portion of the leaf is cut away, and the leaf is quickly re-photographed.

Researchers claim that the experimenter has five working minutes from removing the leaf from the plant to capture the phantom. After that time elapses, the phantom disappears. I bring this up to note that the experimenter must work rather quickly to accomplish everything in this time period.

What could happen to cause a phantom leaf to appear in the second photograph is that during the first photograph, moisture from the leaf could have been deposited on a plate, the moisture forms an outline or a "photocopy" of the leaf. If the leaf was returned to its original position to be re-photographed, when the high-voltage field was re-applied in the second photograph, the moisture forms a conductive path giving the illusion of a phantom leaf.

I don't feel that the leaf must be returned exactly to the original position to form a phantom. People are forgiving of phantoms and seeing an undefined discharge filling in a missing leaf portion is usually sufficient.

In the second case, a pseudo phantom might appear whether or not the leaf was photographed whole beforehand. Leaves have a good deal of moisture. At the cut site on the leaf, a small amount of water might accumulate. If the leaf is pressed down or put under pressure, a small amount of water might be ejected outward into the missing leaf portion. This moisture would form a conductive path for the high-voltage field and show up in the subsequent photograph.

How to fake a phantom

Faking a phantom is easy. Place the entire leaf on the exposure plate with film, connect a ground to the leaf and expose it for ¼ of the time you would normally use. Without removing the leaf from the plate, lift a portion of the leaf and cut a section away (not moving the leaf keeps it in perfect registration for the second exposure). Now, re-activate the Kirlian device to finish the exposure for the remaining ¾ time. When the film is developed, you will see a brilliant leaf with a faint, but perfectly formed phantom formed in the missing section of the leaf.

Beginning the search

My search for the phantom leaf phenomenon begins by assuming that it exists. You might question that my assumption is not being objective and might corrupt my research. My answer is if I didn't think it existed, why bother to look for it? However, I must take special precautions that I do not do anything unconsciously that might falsify my results.

To prevent erroneous pictures, no Kirlian photographs will be taken of the leaves before they are cut. This will prevent any possible imprint being left on the plates from a preliminary picture. The plates will be cleaned between each shot with a furniture wax spray. Little or no pressure will be applied to the leaves to prevent water being ejected. I would be looking for a sharply defined phantom.

My time and budget prevents me from using laboratory-grade Kirlian equipment. Therefore, strenuous controls will not be maintained on the Kirlian device. This is okay because I'm not looking for a subtle effect and I'm not attempting to make a medical interpretation from a corona pattern. This is a simple yes or no situation; I am looking to see if a phenomenon exists. If a phantom leaf does appear in any photographs, I will record the date, time, and frequency of discharge, voltage, humidity, and temperature.

The vast majority of Kirlian researchers are using high-voltage source at high frequencies (ranging from 20 to 200 kHz). At these frequencies, the phantom leaf phenomenon rarely makes an appearance.

It appears obvious to me that any true biological field will oscillate at relatively low frequencies. You can extrapolate this information from chapter 7 on the electrodynamics of life. So, reaching a resonance with a bio-plasmic field would require a low frequency of approximately 7 to 40 Hz (possibly centered at or around 10 Hz). If this is correct, it might explain why the phantom leaf is not often observed by researchers using high frequencies. This would also fit in well with the report made by Choudhury, Kejariwal, and Chattopadhyay from India.

Circuit

To investigate this phenomenon at low frequencies, a new circuit is required. This circuit must be capable of delivering a low-frequency pulse rate. Figure 10-1 details the schematic for this type of circuit.

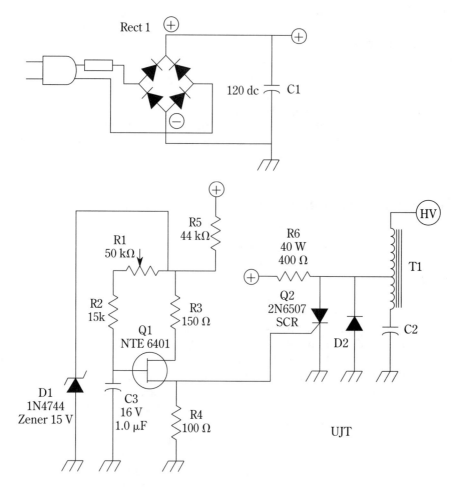

10-1 Schematic of third Kirlian device.

This circuit is capable of generating pulses from approximately 8 to 30 Hz. I will restrict my search to this band of frequencies. Having restricted my range of frequency to just 22 Hz allows me to try variances in technique that would not be possible for me to investigate properly in a large frequency range. Although the HV pulse rate is low, each HV pulse has high-frequency harmonics and components to it.

Figure 10-2 is a photograph of this Kirlian device. There is only one top-mount control for the frequency. The unit is turned on and off using a foot pedal switch. You can see the ⅛" phono socket located at the front of the unit. External wires were connected to the HV source and circuit ground.

10-2 Third Kirlian device.

1st attempt parameters

My first search attempted to duplicate the results obtained by the three Indian researchers: Prof. J. K. Choudhury, Dr. P. C. Kejariwal, and A. Chattopadhyay. These researchers claimed a 50% repeatability in photographing the phantom leaf phenomenon. The researchers used a type-2 grounding. The current was polarized using a single high-voltage diode connected between the ground plate and ground (see chapter 11 for more details). Figures 10-3 and 10-4 show two typical photographs. Figure 10-3 is a paper negative and 10-4 is a sheet film negative.

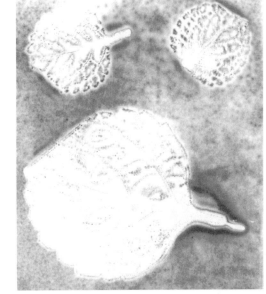

10-3 Paper negative using first search parameters.

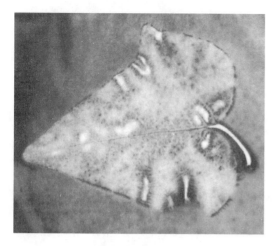

10-4 Film negative using first search parameters.

2nd attempt parameters

In this series, a type-1 ground was used with a polarizing voltage. Figures 10-5 through 10-9 show various attempts on film and paper using this technique.

3rd attempt parameters

In this series, the voltage was not polarized. This allowed a much greater energy output from the corona discharge. However, in using this technique, most of the photographs taken were overexposed. I did not shorten the exposure time to compensate for the increase in the corona discharge so that if a phantom phenomenon was occurring (even faintly), it would have enough energy to form an image onto the photographic material. Figure 10-10 is a paper negative photograph of a number of leaves still attached to their branch.

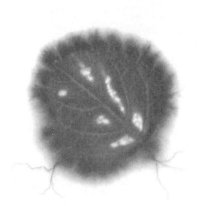

10-5 Film negative of a leaf, 2nd search parameters.

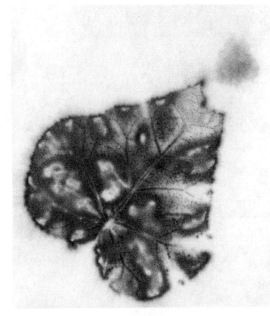

10-6 Film negative of a leaf, 2nd search parameters.

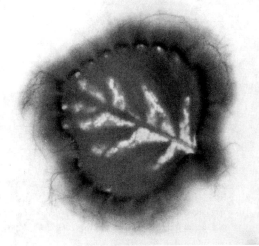

10-7 Film negative of a leaf, 2nd search parameters.

Artifact?

Having shot close to 100 pictures in many different configurations looking for evidence of the phantom leaf, I did detect a partial phantom. I almost threw this particular negative out for being overexposed. While giving it a quick examination, I noticed at the tip of the leaf what appears to be a partial phantom in the missing leaf section in the corona discharge area. It appears as a change in density of the corona discharge.

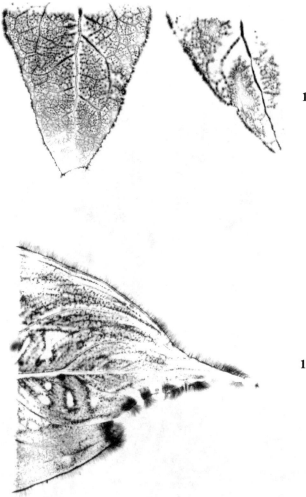

10-8 Paper negative of a leaf, 2nd search parameters.

10-9 Paper negative of a leaf, 2nd search parameters.

The first question I asked myself was what separated the procedure used in taking this picture from the great many photos I shot beforehand. In this photo, I used a leaf that was still attached to a large portion of the plant.

My first thought was that a large section or perhaps the entire plant was necessary for a phantom to appear. I disregarded this conclusion because there is too much literature that suggests this isn't the case.

My second thought concerned impedance matching. Perhaps the impedance (resistance) of the plant branch and my device matched to a point where the "proper" energy density was reached, allowing the phantom to appear.

Note: Because this photograph is overexposed, it is difficult to see the faint image in the original. It would be impossible to see in reproductions, so it was not included as an illustration for this book.

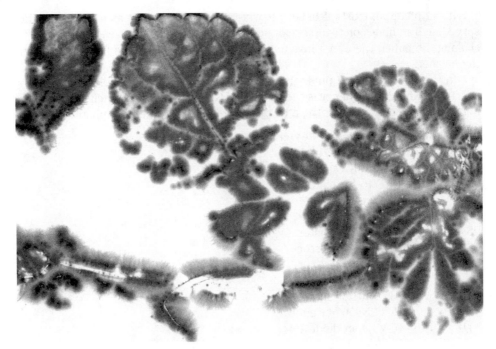

10-10 Paper negative of a branch, 3rd search parameters.

Testing the artifact The experiment was repeated for four different species of plant under a variety of load conditions and techniques. No other phantom phenomenon was recorded in any of these subsequent photographs.

This leads back to the original photograph. This must be assumed to be an artifact. There is a way that this might have been introduced, despite my precautions. It is my belief that the end of the leaf was curled up slightly. During exposure, pressure was momentarily readjusted, causing the curled edge of the leaf to come into momentary contact with the plate. The momentary contact caused the phantom leaf phenomenon to appear in the photograph.

Is this a likely occurrence? No, it is not, but it is still 10000X more likely an occurrence than a new phenomenon. Remember, this assumption is being made only after deliberate testing to replicate the original results failed.

Does the phantom exist?

My search doesn't prove the phantom leaf phenomenon doesn't exist. It means that my scanning of this 22-Hz field didn't yield the phenomenon.

There have been many reports on the phantom leaf, but unfortunately this phenomenon still hasn't been verified. If the phantom leaf does exist, what is it? We can look at the Russian researchers who state that it's a new form of energy that they call *bio-plasma*. If this is the case, it's a pretty safe bet that this energy is not electromagnetic. Or perhaps the phantom leaf is a holographic projection as Adamenko suggests.

If the phantom exists, I believe it will be interpreted best as a field. Consider sprinkling iron filings on to a piece of paper that has a magnet placed beneath it. By shaking the paper, the iron filings form a picture of the magnetic field surrounding the magnet.

In the case of Kirlian photograph, consider the high-voltage electricity as the iron filings and the frequency is the shaking of the paper. The electricity forms channels (sparks or streamers) into paths of least resistance within the phantom field.

Parts list for third Kirlian device:

* Rect1	200-V 1-A rectifier
* C1, C2	2-μF 250-V capacitors
C3	1-μF 16-V capacitor
R1	50-kΩ potentiometer
R2	15-kΩ ¼-W resistor
R3	150-Ω ¼-W resistor
R4	100-Ω ¼-W resistor
R5	44-kΩ ¼-W resistor
R6	400-Ω 40-W resistor
* Q1	UJT 6401 or equiv.
* Q2	SCR 2N6507 or equiv.
* D1	15-V Zener diode 1N4744 or equiv.
* D2	10,000-V 10-mA diode
* T1	HV autotransformer
Misc.	Copper-clad exposure plate, case, line cord, switch, PC board.

* = Available from Images Company

Images Company
P.O. Box 140742
Staten Island, NY 10314
(718) 698-8305

11
Photographing tips

Animals, plants, and minerals are the categories that are used in this chapter to provide tips that you can use to create successful Kirlian photographs. These are broad encompassing categories and should cover most objects and specimens whenever you attempt to shoot.

General

These beginning photography tips are listed under the general category because they apply, regardless of the type of object.

Exposure times

In general, short exposures provide greater resolution and show more intricacies of the subject. Longer exposures tend to blur delicate details, but provide a greater overall brightness.

UV filters

Do not use UV filters. UV filters will effectively block the corona discharge image from the film.

Color filters

Color filters can be used. Color plate 9 shows a leaf shot with a 35-mm camera and a transparent electrode. A red transparent filter was held in front of the camera during the exposure.

Using a B/W safelight with color film

I have had good success in using a red transparent plastic as a filter to block light from a green safelight. The green safelight is used with holography film and is available

from the Images Company. The red transparent material is taped on top of the expo-
sure plate. The color sheet film is slid under the transparent material in complete
darkness. Then, the green safelight is turned on. The object to be photographed is
placed on top of the red transparent material and the exposure is made. After the ex-
posure, the safelight is turned off, the film is removed from the exposure plate, and it
is stored in a light-tight box for development. This procedure can also be used with
Polaroid 600 film.

Color plates 4 and 5 are Polaroid pictures of leaves shot using this procedure. I
had tried using green transparent material with a red safelight. However, this did not
work as well.

Grounding

In addition to the types of grounding already described elsewhere in this book, there
are two additional variations.

The first variation adds a diode between the object being photographed and the
ground. This forces the current to flow in just one direction, creating a unipulse or
"polarized" current from the Kirlian device (Fig. 11-1). Applying this technique usu-
ally requires an increase in exposure time, but it reveals details in the objects that
cannot be seen in the bi-polar pulses. The diode will work better facing in one direc-
tion than the other, either the B or C in Fig. 11-1. The diode used must be a high-volt-
age type, something around 10,000 V at 10 mA. This type of diode is available from
Images Company.

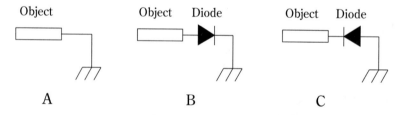

11-1 Schematic of the diode grounds.

The second variation is to place a high-ohm resistor between the object and
ground (Fig. 11-2). This reduces the current flow. This technique is useful when
short exposure times still overexpose the film and blur fine details. Use a resistor
that is rated between 1 and 10 MΩ.

Although the illustrations look as if an earth ground is being used, many times it
is simpler and more convenient to use a circuit ground.

Spacing/air gap

The spaces (air gaps) between the components in the Kirlian set-up greatly affect
the discharge pattern. Space can be adjusted by using paper sheets between the dis-
charge plate and film or between the film and the object. Other dielectric materials
can also be substituted for the paper.

Object

11-2 Schematic of the resistor
ground.

1 Meg
$1/4$ Watt resistor

Spark field

An interesting effect can be created by sprinkling iron filings over photographic film
positioned on the discharge plate. By bringing a ground wire close to the filings and
activating it, the discharge will cause long random sparks to form across the film. You
can try positioning an object on the plate and having the sparks emit from the object.

Models

For complicated shoots, it is to your advantage (if possible) to set up a model. Fig-
ure 11-3 illustrates the point. I was using an 8"-x-10" color transparency film. The ob-
ject I was shooting was a plant with large leaves. Rather than try to set up the leaves
and stems properly on top of the film in the dark, I made a model. I taped the leaves

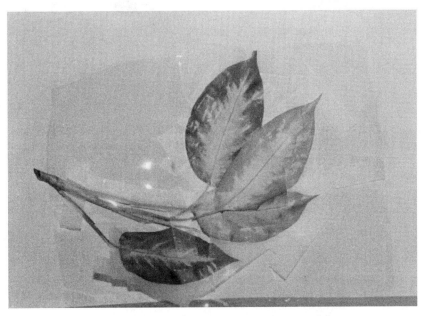

11-3 Photo showing plant model on plastic film.

individually to a thin sheet of transparent plastic. I made sure that the leaves folded over one another the way I wanted before I began taping them in place. If performed correctly, no tape marks show in the final print. The model is used plastic sheet side down on the film. When I finished, I had my plant attached to a sheet that I could easily place on top of the film. An added bonus is that I could attach and leave the ground wire in place between shots.

Animals

The first rule when photographing live animals is to *never* let the animal come in contact with a ground while being photographed. This can lead to a nasty, and possibly lethal, shock.

In the case of photographing humans, there is no reason to ground the body. The body's capacitance and large surface area acts like an antenna, plus additional grounding through shoes to the floor is sufficient to cause a corona discharge without being technically grounded.

So, under no circumstances allow a person you are photographing to come into contact with a ground. In addition, you should not photograph anyone with heart problems or a pacemaker.

Experimental work has been accomplished making Kirlian photographs of the face. Common areas that people make Kirlian photographs of are finger pads (Fig. 11-4). Most any body part can be photographed; see the photographs of the ears and the lips in Figs. 11-5 and 11-6.

11-4 B/W paper Kirlian photo of finger pads.

11-5 B/W paper Kirlian photo of an ear.

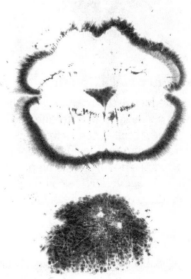

11-6 B/W paper Kirlian photo of lips.

One tip you may want to try when shooting fingers is to clean the area with rubbing alcohol. This removes any dirt and oils and provides a different corona discharge.

If the animal you are shooting is too small to cause a discharge by itself, simply hold or touch the animal with your bare hand. Your body capacitance will then cause a discharge through the animal.

Marine animals make interesting subjects to shoot. I made a few photographs of fish and starfish (Figs. 11-7 and 11-8 show two B/W negatives). C-15 and 16 show the same subjects in color.

It's important that the surface of the marine animal be relatively dry, or excess water will run onto the film and create a water spot. This in itself isn't too bad until the Kirlian device is activated. The water spot will glow with the corona discharge just like the marine animal. This makes a very splotchy picture.

Another idea you might want to try is to place a piece of rice paper between the marine animal and the film. This usually improves the pictures.

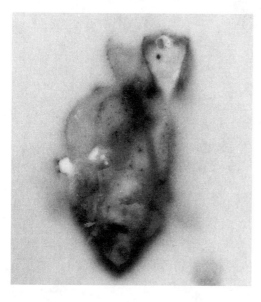

11-7 B/W film Kirlian photo of a fish.

High frequency and skin effect

In general, the higher the frequency of the Kirlian device, the less likelihood of getting or giving a shock. At high frequencies, most of the current travels near the surface of the object, called the *skin effect*. This high-frequency current reduces the shock hazard. However, it has been reported that extremely high-frequency Kirlian circuit photographs do not show the physiological and psychological changes.

The high-voltage inductive coil used in the Kirlian circuits outlined in this book cannot be made to operate at high enough frequencies to eliminate a shock hazard.

Plants

The leaf is probably the most common Kirlian subject. With leaves, you have the ability to connect a ground wire to the subject. This provides a bright more powerful

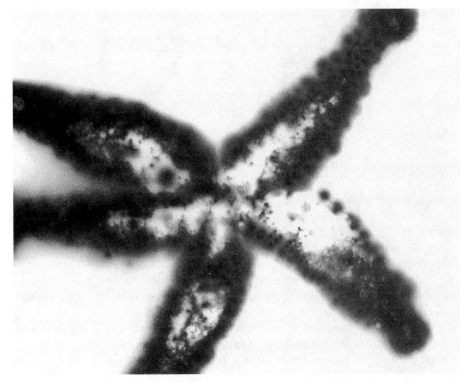

11-8 B/W film Kirlian photo of a starfish.

corona discharge. Sometimes this discharge is so great that you lose the fine intricate details of the leaf. What you can do to circumvent this problem is add a 1- to 10-MΩ resistor to the ground wire, as described in the general section. This limits the current flow and allows the details to be photographed without blurring.

You can also use a high-voltage diode in between the object and the ground. Remember by using a diode ground, the current can only flow in one direction. This is called a *polarized* or *unipolar* (meaning one polarity) corona discharge photography. The diode will usually work better facing one direction than the other. Use the direction that provides the greater discharge. This type of photography usually shows greater detail than the bipolar discharge. This has also been cited by the Indian researchers as a requirement to obtaining photographs of the phantom leaf.

One hint you might want to try when shooting leaves is to place the ground wire into the pot that contains the plant. This allows you to shoot "living" leaves of the plant without damaging and removing leaves from the plant. Grounding the plant usually causes no harm to the plant.

You can try your hand at photographing common vegetables, such as a cross section of: carrots, tomatoes, cucumbers, apples, oranges etc. Figure 11-9 is a B/W sheet film negative of a carrot cross section.

11-9 B/W film cross section of a carrot.

Minerals

Minerals in this classification also include metals. The most common metal shot is coins. C-9 shows six Roman coins. These coins are about 2000 years old. C-5 shows a United States quarter photographed with the transparent electrode and a 35-mm camera. C-11 shows a house key. Figure 11-10 is a black and white film negative of a few U.S. coins.

Coins, like leaves, are connected to a ground to provide a brighter discharge. Coins aren't the only metallic object that you can photograph; try metal gears, printed circuit boards, paper clips, keys, etc.

The main scientific avenue of research that I am aware of utilizing metals is nondestructive testing. Nondestructive testing of materials attempts to find flaws in materials that might cause a premature failure. This is critical testing method for components used in military and commercial aircraft, as well as in the nuclear industry.

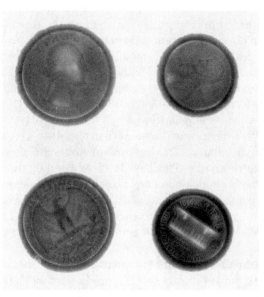

11-10 B/W film of U.S. coins.

12

The healthy role
of skepticism

I remember a few years ago I met with another researcher. The researcher began explaining his psychological work using Kirlian photography with people and patients and the conclusions being drawn from the work. I became pretty interested in this work and began asking questions about the data, such as the experimental group size, the control group size, in group variance, etc. Rather than answer any of my questions, the reply to all my questions was, "Oh, so you're a skeptic." No other information was forthcoming. I hadn't been aware that being a skeptic was considered a bad thing.

Why are scientists skeptical of Kirlian photography? Skepticism is essential. Just think of the chaos that would ensue if each new belief was accepted with unskeptical deference.

Before science changes or modifies its belief systems, it must have irrefutable proof to do so. It must be able to repeat experiments and scrutinize the resulting data. While the pursuit of Kirlian photography for certain types of medical diagnosis and prognosis is a worthwhile endeavor, there is no compelling reason to proclaim that there is any new type of emanations from living tissue. If the time arrives where the phantom leaf is verified, then this situation will change.

What happened in the beginning of the research with Kirlian photography? The nonscientific researchers lost their skepticism; they were looking for proof of the reported Russian's bio-plasmic ethereal body. They wanted to verify the Russian reports with their own research. So, explainable and electrically measurable physiological changes detected by Kirlian photography were offered as proof of the bio-plasmic energy.

Unfortunately, these unjustifiable claims prejudice the scientific communities and prevent many legitimate researchers from exploring the field. Those researchers that continued to look into Kirlian photography were not encouraged. The continu-

ing stance of the scientific community, in general, believes that the corona discharge can be explained using known physical and biological principles.

Lately, mainstream science appears to be getting a little more tolerant of Kirlian photography research. I believe more legitimate studies are being conducted and are beginning to filter into the scientific literature.

Suppliers Appendix

Complete Kirlian devices are available from:

Mankind Research Ltd. Inc.
1215 Apple Ave.
Silver Spring, MD 20910
(301) 587-8686

Images Co.
P.O. Box 140742
Staten Island, NY 10314
(718) 698-8305

Index